D1123183

ON THE PLAINS

PETER BROWN

ON THE PLAINS

WITH AN INTRODUCTION BY KATHLEEN NORRIS

DoubleTakeBooks

PUBLISHED BY THE CENTER FOR DOCUMENTARY STUDIES IN ASSOCIATION WITH W. W. NORTON & COMPANY, NEW YORK • LONDON

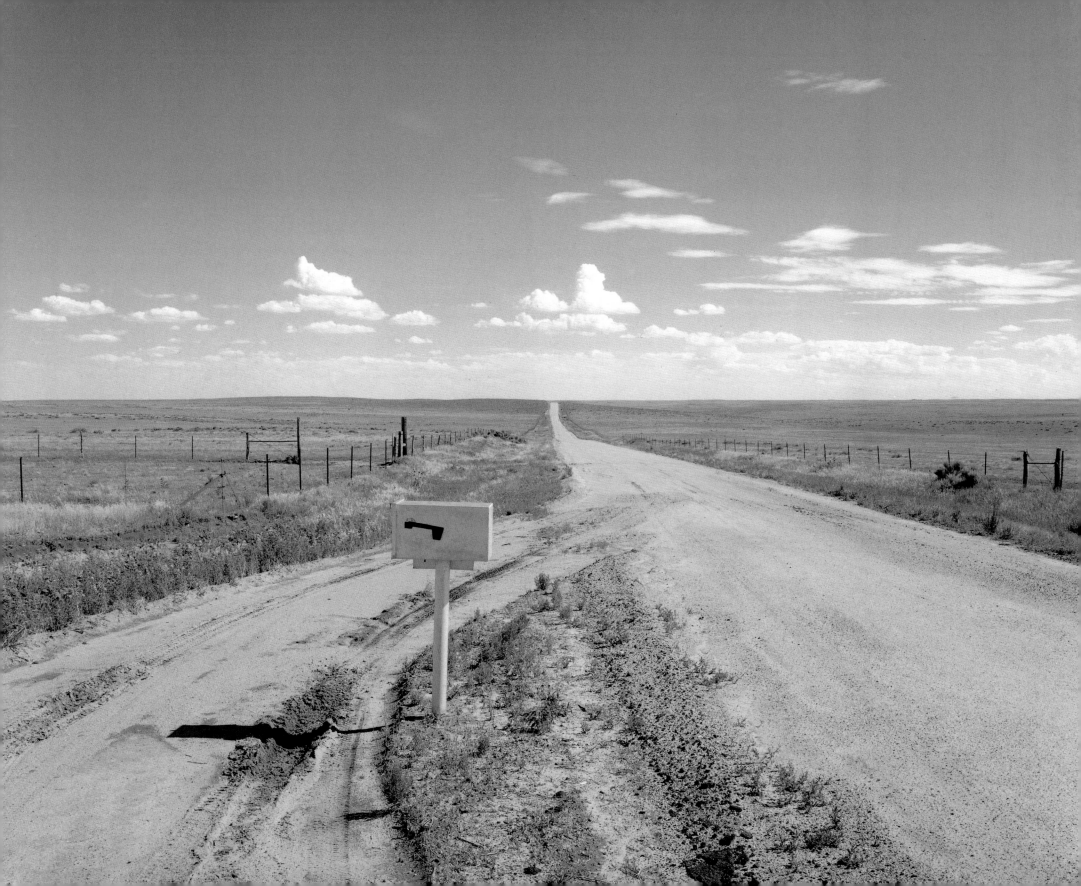

On the Plains
© 1999 by Peter Brown
Introduction © 1999 by Kathleen Norris

All rights reserved
Printed in Singapore
First Edition

The text of this book is composed in Berkeley.
Manufacturing by Tien Wah Press
Book design by Molly Renda
Cover photograph by Peter Brown

Library of Congress Cataloging-in-Publication Data
Brown, Peter (Peter T.)
On the Plains / Peter Brown : with an introduction
by Kathleen Norris
p. cm.
"A DoubleTake book."
1. Great Plains—Pictorial works.
2. Great Plains—Social life and customs—Pictorial works.
3. Landscape—Great Plains—Pictorial works.
I. Title
F595.3.B76 1999
978—dc21
98-46999 CIP

ISBN 0-393-04730-X (Norton)

W. W. Norton & Company, Inc.
500 Fifth Avenue, New York, New York 10110
http://web.wwnorton.com
W. W. Norton & Company, Ltd.
10 Coptic Street, London WC1A 1PU

1 2 3 4 5 6 7 8 9 0

DoubleTakeBooks publish the works of writers and photographers who seek to render the world as it is and as it might be, artists who recognize the power of narrative to communicate, reveal, and transform. This publication has been made possible by the generous support of the Lyndhurst Foundation, the National Endowment for the Arts, the Graham Foundation for Advanced Studies in the Fine Arts, and Diverse Works and the Cultural Arts Council of Houston.

DoubleTakeBooks
Center for Documentary Studies at Duke University
1317 West Pettigrew Street
Durham, North Carolina 27705

To order books, call W. W. Norton at 1-800-233-4830.

For Jill & Caitlin

and in memory of Jack Fryar

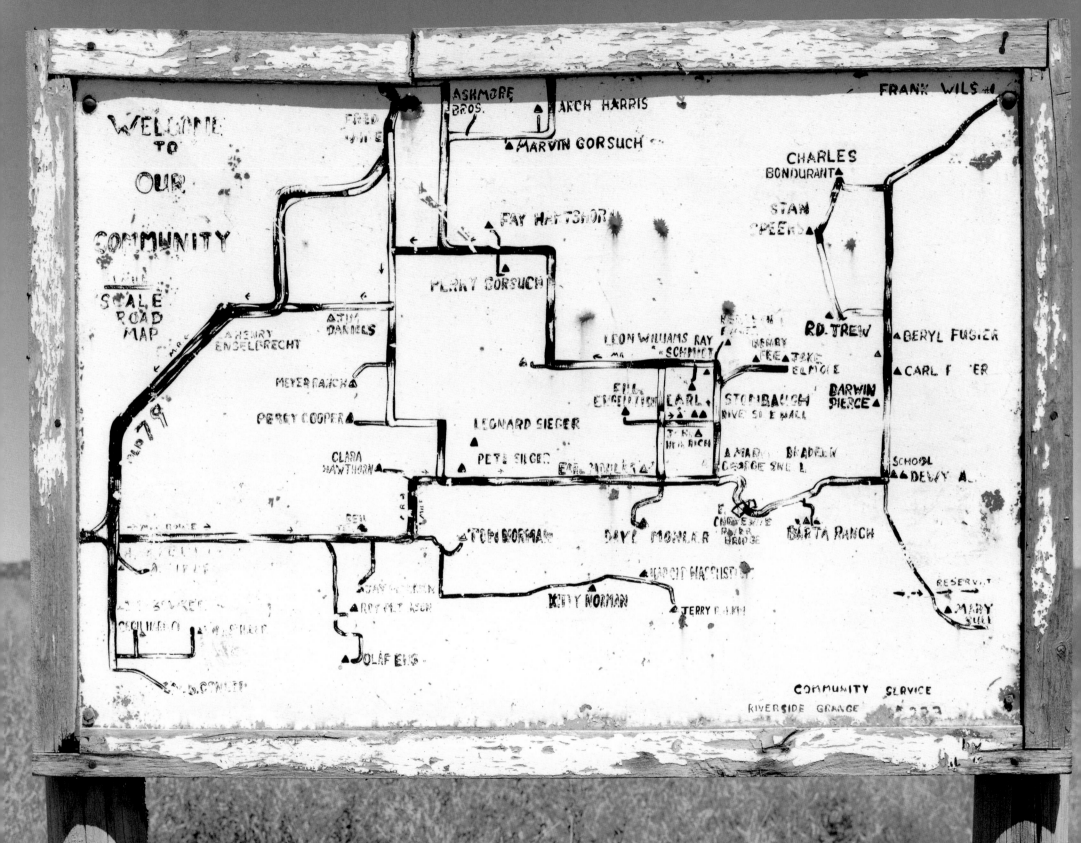

CONTENTS

ON THE PLAINS

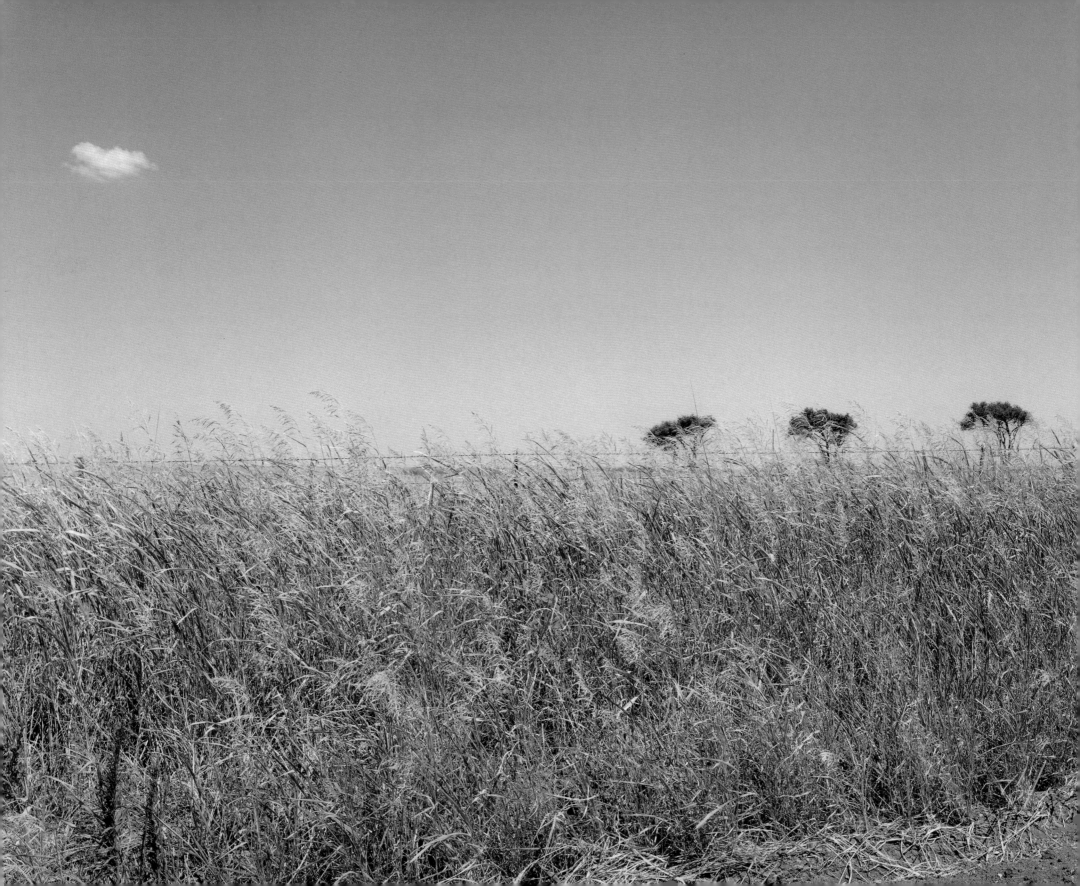

INTRODUCTION BY KATHLEEN NORRIS

I often think that I am a frustrated painter, and that much of my writing about the Plains is simply an attempt to paint the place with words. But there don't seem to be words, let alone colors, to do justice to the land and skyscape that surrounds me. Often on my pre-dawn strolls, I find that the sky to the east is best described as painterly. Each morning might reveal another of the dazzling array of styles in God's paintbrush, evoking El Greco, or Manet, or Magritte. Morris Louis, Helen Frankenthaler, David Hockney. The setting moon plays tricks on my eyes: it seems to be utterly transparent one moment, in the next it moves closer to the horizon, finally becoming a pale, golden crescent that is indistinguishable from the tops of hay bales in a distant field caught in the light of a newly risen sun.

I am frustrated also because those of us who live on the western Plains have not been particularly well served by the visual arts. All too often the quotidian splendor of our sunrises and sunsets has been depicted badly, in sentimental renderings of purple barns at dawn, silver coyotes howling at the moon. We are still waiting for a Van Gogh to render the giddy golds of our wheat fields, the depth and variety of color in our dew-soaked pasture grasses. We have yet to inspire the Georgia O'Keeffe who can interpret the quality of our light in no-nonsense terms.

For most Americans, the Plains are an unknown region, except for an occasional (and by now, stereotypical) glimpse of an abandoned windmill or derelict homestead that does little to dispel the perception that much of inner America is a sere and barren wilderness, better left unseen. "But what is there to look at?" is a question commonly asked of Plainspeople by those who dwell in more spectacular landscapes, who treasure the drama of mountains, seacoast, or great urban centers, but who consider the vast reaches of the Plains to be unspeakably dull. "What is there to see?"

Peter Brown can tell us, if we let him. In his years of roving over our blue highways, photographing the Plains with an artist's keen eye, he has made witness to a region that I call home, but which *Newsweek* has aptly termed America's

"Empty Quarter." It is the western Plains, a rural America that is many hundreds of miles from any city—my town in South Dakota, for example, is six hundred miles from Denver, five hundred from Minneapolis—and is populated by many more deer, antelope, buffalo, and cattle than human beings. Traffic is never a problem, but the specter of drought is a constant threat.

To a Plains person such as myself, Peter Brown's photographs stand up to those questions that I grow weary of hearing: How can you stand to live out there, in the middle of nowhere? What in the world is there? In studying and revealing what he terms "the commonplace landscape of the Great Plains," Brown has accomplished something that is far from common. The *American Heritage Dictionary* defines "commonplace" as "having no remarkable features, characters or traits, ordinary." In a sense Brown has made a visual commonplace book, a journal of quotes from a landscape.

The images in this book suggest that as empty as this place can seem, a person might never weary of looking at the land and sky. In it I find the landscape I know, an expanse of grassland over which a storm is passing. The rain is visibly forming, pulling away from the cloud, and beginning its stretch toward earth. I find a winter whiteout in which a snowy sky and hoarfrost-covered ground seem to have merged, erasing any notion of a horizon. I am grateful to Brown for allowing the Plains their true, subtle colors, their constant play of sun and shadow on grassland, a phenomenon that makes me want to sit still and watch the changing light. One image, which might have been sentimental, instead is glorious. The western wall of an abandoned church is pure gold as the moon rises in the east. The weathered wood is transfigured in a way that is no less miraculous for being thoroughly accurate. All Brown had to do was be there, and to trust the light of a late afternoon.

It is gratifying to my practiced Plains eye to find so much going on in these photographs of what might seem like nothing, at least nothing extraordinary. Enormous fields of sage or grass, trees standing alone, hawks and swallows on the wing. A seeming emptiness that is full of life. In one photograph from Kansas, the fecundity of both corn and black-eyed Susans that have "volunteered" in the gravelly shoulder of a dirt road is all but overpowering. We are grateful for a glimpse of sky. And, true to the experience of those who live on the Plains, the photographs reflect the weather as a genuine presence. A menacing sky in the distance, the kind that stops me in my tracks and makes me exclaim, with no small sense of awe, "They're getting *weather* over there."

In the urban areas in which most Americans live the weather can appear to be primarily an adjunct to human emotions. A clear, sunny day is a mood-lifter, a rainy one is a downer, and a bad storm can be a major inconvenience,

snarling traffic and commuter trains for hours. But for the dryland farmers and ranchers of the Plains weather is a matter of making a living or not. Rain at the right time of year can allow a family to remain on the land for another season. Rain at the wrong time, or a severe hailstorm, can wipe them out, sending them off the land. In one of my favorite photographs Brown shows us evidence of a storm that has just passed over, a late summer rain that has left tall weeds heavy with seed bent by the side of a dirt road, puddles in the ruts that will no doubt turn back to dust in a matter of hours.

In picture after picture Brown captures the largeness of the western sky. (Montana has laid claim to being "big sky country," but the term applies to all of the western Plains.) At times we have a Magritte sky: clear, blank blue with innocent-looking puffs of cloud drifting along in formation, like synchronized swimmers. They look painted on, a wonderful joke. At times the sky seems a more abstract expression; gray, milky clouds swirling overhead, like the finger paintings of an enormous, unruly child. Or long streaks of gun-metal gray appear in the peachy glow of a sunset, bisected by bolts of lightning silently announcing the coming storm. Soon you will feel its stiff breeze, and hear the rolling thunder.

Summer storms come up fast on the Plains, with dark clouds closing in, looming and threatening, a brooding presence. Under such a sky human existence appears fragile and tenuous. In one of Brown's photographs a young man and a child stand in bright sunlight in front of a small house with hail-damaged shutters and a rusty air conditioner. The man's well-worn jeans, the old car, suggest that he is a laborer. He is also a proud and protective father, placing his hand gently on his daughter's back. They both smile, shyly; one senses that they will weather the coming storm, as they have those in the past.

As a storyteller, I appreciate the narrative quality of Brown's images, tales told with such subtlety that they often require rereading. They consistently reward a second look, a third. In one photograph Brown evokes the presence of a strong prairie wind in the ruffled surface waters of a slough, in the bend of grasses, and in a stand of feathery foxglove. On second reading, a fence post declares the place a pasture. The pond is not a slough but an aquifer lake; a windmill in the distance attests to human use and labor.

Never artless, Brown offers a plowed field, or a long, straight road as classic lessons in perspective. On his Plains, trees on the horizon might indicate the presence of a homestead, or a town. And on its outskirts we might find a cemetery barren of even a shrub, its silent tombstones testifying to a brutal history of loss, and to the dearth of medical care in the homesteading days. In one family plot lie the graves of children who died at six months, a year, three years, and eight years of age, in the years from 1898 to 1908.

I admire Peter Brown's insistence on the importance of the human story on the Plains, his willingness to include small towns and cities in this portrait of the land. It's a brave photographer who will allow electric and phone lines their ubiquity, who will include so many roads and railroad tracks in what might be considered "nature" photography. Not long ago Wendell Berry stirred up a hornet's net when he dared to ask why no Sierra Club calendar photographs had people in them. The contemporary unease over our presence in nature is understandable, given the environmental damage that we inflict. But to depict the world we live in as dramatic scenery sans *homo sapiens* is to indulge in a romanticizing of nature that we can ill afford.

We humans are animals, after all, mammals who express both hospitality and territorial pride by painting a sign, a crude wooden road map, and installing it at a country crossroads. Such signs as the one that Brown has photographed in eastern Colorado are common in the West, placed at crossroads along gravel township roads. They can seem mysterious to a newcomer, but the cryptic inscriptions—2N 1E—have a practical purpose, offering directions to the ranches that are spread out over the many square miles that constitute the "neighborhood."

We are also persistent community-builders, even when our sacred gathering place consists of a concrete slab with picnic tables under a tin roof held up by poles (and off to one side, perhaps a tin-sided pole barn for wedding dances, baby showers, anniversary parties, and funeral dinners). And we persist in bearing our hopes into the future, despite the evidence of the past. On the outskirts of Vera, Texas, a woman showing off the Vera Community Center stands in the picnic area framed by one set of poles, while an abandoned farmhouse in the distance is perfectly framed by another.

The United States government has traditionally defined frontier regions of the country as those having two or fewer persons per square mile, and most of the region Brown has covered on his travels would qualify as frontier. It is a region that proves the truth of Gertrude Stein's remark that "in the United States there is more space where nobody is than where anybody is." Frank and Deborah Popper, authors of the provocative "Buffalo Commons" theory, once told me that if one were to magically transpose the population density of Perkins County, South Dakota, where I live, onto the island of Manhattan, there would be fewer than fifty people left in Manhattan. And my county is typical of those on the western Plains, which I define as the land west of the 100th meridian running through western Texas up to North Dakota, to the 107th meridian in eastern New Mexico, Colorado, Wyoming, and Montana. In all that area only two cities (Lubbock and Amarillo, Texas) have populations greater than 100,000. My county is typical also in that it is steadily

losing population by outmigration. In 1910, at the height of the homesteading boom in western South Dakota, Perkins County had a population of over 10,000; it is closer to 3,000 today. The 1980s alone saw a 20 percent drop.

Still, with 1,600 people, the town where I live is by far the largest in northwestern South Dakota, an area constituting more than 15,000 square miles. In driving through even more sparsely populated regions—western Texas, or eastern Colorado—a traveler discovers that even a town of 300 can feel huge, a welcome oasis after the seventy or so miles from the last town, the last gas station. And I am grateful to Peter Brown for so faithfully depicting the human hospitality of these dusty little oases.

Someone at the Dimmitt Meat Company in Dimmitt, Texas, for example, has taken the trouble to install tubs of red flowers on either side of a bright red door. The few red blossoms are visually welcoming, as the building itself is a stark, white stucco. The geraniums of Dimmitt remind me of Elizabeth Bishop's poem "Filling Station," with its description of a gas station, evidently family-run, with an incongruous begonia, stained doilies with cross-stitched embroidery on aged but comfortable chairs, and carefully arranged oil cans in the window. It all seems to say that someone tends all this, someone cares, or even, as Bishop concludes, "somebody loves us all."

The storefront of the Cake Palace in another Texas town, with its neat red window shades and hand-painted sign is a marvel of survival. It declares that someone is here, that cakes will go on being made, despite the empty lot next door. Another building stands improbably by itself, its false front announcing in thick black lettering, H. A. C. Brummett, Lawyer. But the tin roof of the front porch has rusted, and the slender posts holding it up are beginning to buckle and bend. Tufts of grass emerging out of the cement pad at the front door suggest a life's work come and gone in this tiny frame building, an outpost of civil order in an untidy world.

The world of these photographs reflects an old-fashioned civic pride on the part of people who are frequently told that they live in a backwater, a place of no worth. Such vital institutions as the city hall, general store, church, war memorial, and volunteer fire department are all given their due by Brown. He allows Plainspeople their names, their histories, and their pride: the weedy little baseball stadium in View, Texas, is dignified by its designation as "Henry Beaird Stadium," and its location is marked by those most American of street names, the august intersection of "Grand" and "Main."

When Brown shows us people, he reveals denizens, human beings who might be said to have been naturalized in the

region and who are as plain as the land around them. People whose faces convey a lifetime of squinting under the harsh glare of a big sky. A pecan salesman in coveralls, his few bags of nuts situated on the hood of his dusty old car. An elderly man and woman sitting on the porch of their company houses, the man seated next to an empty chair, evidently kept for company, the woman next to the few scrawny blossoms in her hanging planter as bright as her toenail polish and the flowery print of her house dress. (If you don't know what a "house dress" is, find an elderly woman on the Great Plains and ask her.)

For me, Brown's photographs are full of the mysteries of small-town and rural childhood on the Plains. Summer is all too brief, and children take full advantage of it, skinned knees notwithstanding. A municipal swimming pool dug into a field on the outskirts of town is a precious thing, doubly so if a knobby hill has been employed to provide a water slide. It is worth standing in line for, an activity with which small-town people are normally unfamiliar.

Rural youth grow up knowledgeable about matters of wildlife, soil, and sky—a boy I know has had a blissful spring and summer keeping a close eye on a nest of golden eagles on his family's ranch—but the minute they turn on the television set or VCR they are relegated to partaking of American culture from the sidelines. Their own history within the small town will be preserved for a time in places like a snow-dusted football field that overlooks the open country of Wyoming. The names, and the dreams, of the boys who have played there hang on for years in the town, which has made a considerable investment in floodlights and stands for the stadium.

The children in this book, like most small-town children I know, seem to lack any fear of the stranger, even a photographer who stops to photograph nothing at all—for example, an old but still strangely bright advertisement for paint on the weathered wood of a downtown building. Two small boys in colorful striped sweaters have caught Brown in the act. Why not be in the picture? Why not mug for his camera?

High above them, the words "Komac Colorizer Paint" come straight at the viewer, looming out of the drab, once-green wall. That hint of green reminds me of the surprise that Dorothy, lately of Kansas, finds awaiting her in the Land of Oz—not only color, but the promise of the Emerald City. These boys are having fun. One holds his mouth open, as if showing off a tooth that has newly loosened, while the other spins dreamily, arms outstretched, in the way that children do when they are determined to make themselves dizzy. I suspect that they are celebrating in their own way the presence of an exotic stranger in their midst. My father once told me of an incident from his own childhood in

the remote outpost of Faith, South Dakota, in 1929. As long as he could remember, coffins had been carried to the cemetery in buckboard wagons drawn by a team of horses. The first time a genuine hearse appeared in town, my father and the other children assumed that it was the advance car for a circus, and formed a noisy and enthusiastic parade behind it.

Part of the narrative that this book tells is of contemporary history on the Plains. Chances are those children under the paint sign in Edgemont, South Dakota, will be gone by the time they are in high school. And as the land empties out, and the small towns fold, the larger cities on the Plains are burgeoning. The grassy pastures of the small family ranch are giving way to the bare, packed dirt of the feedlot, the factory model of cattle raising. The hand-lettered signs and haphazard, lively architecture of small towns are giving way to the deadened uniformity of chain stores. The dreariness of a K-Mart at the edge of a Colorado town is made even sadder by the celestial light of a sunset, and the mountains that peer over its roof.

This new urban growth has been made with scant regard for history, order, or indigenous environment, and still less for beauty. And Brown does not flinch from showing us the daunting ugliness of strip malls and minimarts that we have come to take for granted along the highways leading to and from American cities. In Ardmore, Oklahoma, a broken-down sign for what must be a broken-down motel still promises "Refrigerated Air." And in Hereford, Texas, an Italian Renaissance cherub astonishes by his presence in the fountain of a restaurant across the street from a Texaco station and grain elevators. One senses that the statue comes from restaurant supply; still, its presence signifies the memory of another era, a flowering of culture in which beauty was still considered fundamental to civic life.

Brown has managed to find a kind of beauty in even the most industrial aspect of the new Plains geography. With his eye for color and composition he has caught a complex of gigantic elevators at Hartley, Texas, painted stark white with a base of blue. A two-toned pickup truck seems at play with the monsters, reversing the order: blue on white. A boy in a red cap, dressed in blue shorts and white athletic socks, bisects the baseline of one of the elevators, and tiny red construction flags wave in the foreground, the wind blowing them in the same direction that the boy is going. An assortment of guy wires and electric and phone lines in the fore-, middle-, and background make a lively, if silent, commentary on the scene.

We are relieved to find that at the end of the book, Brown takes the road out of town, back into the open, back to the

smaller towns, and the land, where we find a barbed wire fence that has become a prop for rural humor; on the top of each post, as far as the eye can see, is an old boot. In case you missed it, they seem to say, in case you took this fence for granted as part of the rural scenery, it was hard labor in boots such as these that set each fence post and keeps the whole apparatus standing. A town or city is too cramped for so large a rude and personal gesture. But the west Nebraska countryside can laugh it off, laughing along with these westerners, who evidently died with their boots off.

The image that remains with me as I close the book is that of looking down the straight path of a section line road. This sectioning was originally conceived by Thomas Jefferson, who used a compass and a ruler to lay a grid on the American landscape, in the hope of furthering democracy. The roads that resulted demark the boxy townships of the Midwest and, amended somewhat for the rougher terrain of the Plains, have become the threads that connect the human inhabitants of isolated farms and ranches. They provide a way for rural people to come and go from their fields and pastures and also their nearest "market towns," which may be forty or more miles away.

These roads allow a photographer in, and all too often they provide the young of the region with an escape route, at first on weekend nights, and then to college, and then to a larger, seemingly more glamorous and definitely better-paying world. These humble rural roads, which Peter Brown has captured in all seasons, are what Jim Burden, Willa Cather's narrator in *My Antonia,* remembers most clearly about the Nebraska of his youth. Having become a well-traveled urban person with a demanding career, he says that "the sunflower-bordered roads always seem to me the roads to freedom." He does not specify whether that freedom is best found in going to or from the farm.

It takes time to appreciate the Great Plains, to begin to comprehend why it is that some people are proud to call it home, and many others, who have left, would be glad to return. I am grateful that Peter Brown has taken the time to document a place that can't be grasped on the fly, whose nature is best appreciated in the slow lane. I only wish that he had been with me and my husband on the day we followed an ancient and battered pickup truck through a little western town. Two elderly men in tractor caps shared the front seat. They couldn't have been going much more than ten miles an hour. When we reached the highway on the outskirts of town the driver veered sharply to the right, a sure sign to us that he intended to make a left turn (without signaling; surely everyone in town must know that he habitually turns down that road). I have no photograph but can summon up the dusty, windy day, and the dun-colored truck, pocked with rust. The dented rear bumper sports a tattered black bumper sticker whose message in white letters is still loud and clear: "Every Day Above Ground Is A Good Day."

Maybe because our landscape is so large, and our survival in it so flimsy a proposition, Plainspeople generally lack the edgy whininess over small matters that marks contemporary society. Ranchers and farmers do complain ceaselessly, but it's a kind of game: they fret over the weather, which is beyond their control. The stuff and bother of the modern inconveniences is not worth their attention. Once, as I seated myself on a typically full flight from Minneapolis to Bismarck, North Dakota, the woman next to me began fussing loudly over the crowded conditions, the narrowness of the seats, the likelihood that her suit jacket would emerge from the overhead a wrinkled mess. The man next to her, at the window, a large man in jeans, a large, engraved silver belt buckle peeking out from a big gut, looked her over curiously but benignly, as if she were some exotic life form he had never before encountered, and said in a deep voice, "Beats walkin'." With enormous, callused hands he put his cowboy hat over his face and went to sleep.

Ranch friends of mine have told me that a niece who was raised in the urban East, and had traveled all over Europe, once commented that western South Dakota was the most foreign place she had ever been. It is this hidden America, in all its otherness, that Peter Brown has presented to us, with its complexity and simplicity, its banality and beauty, its ordinary grace.

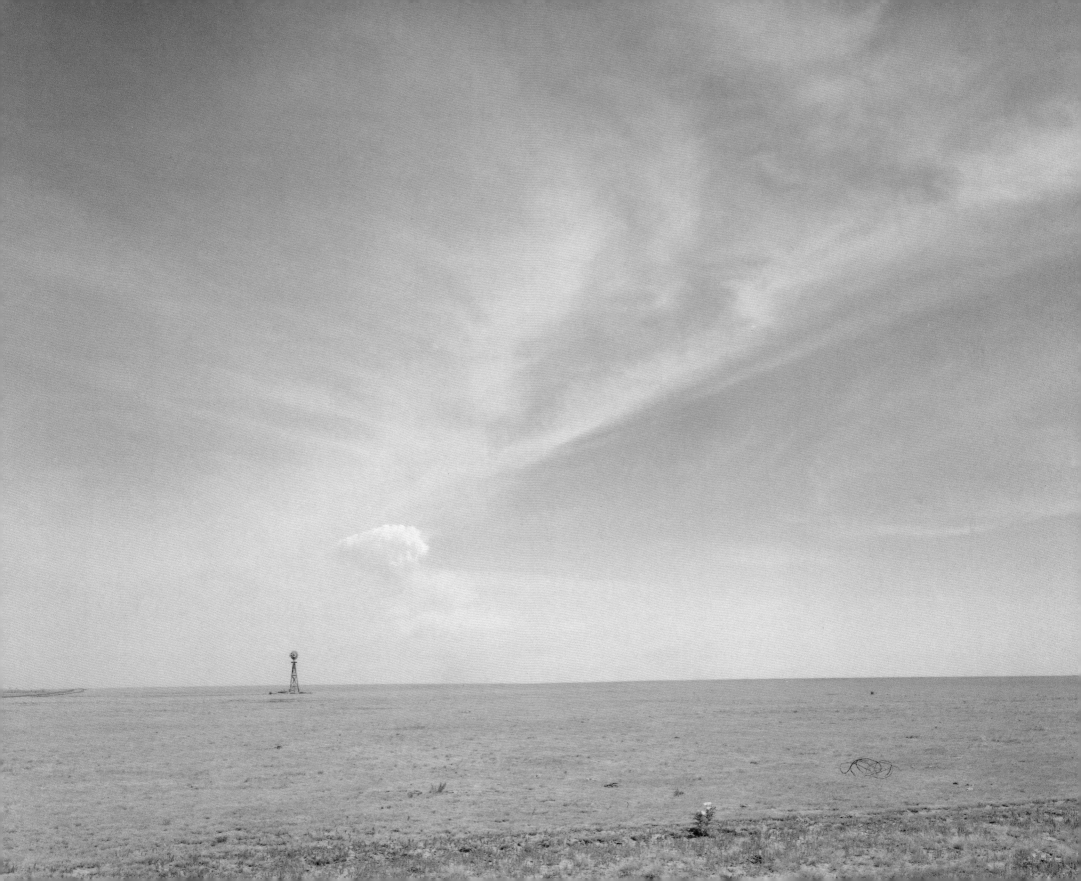

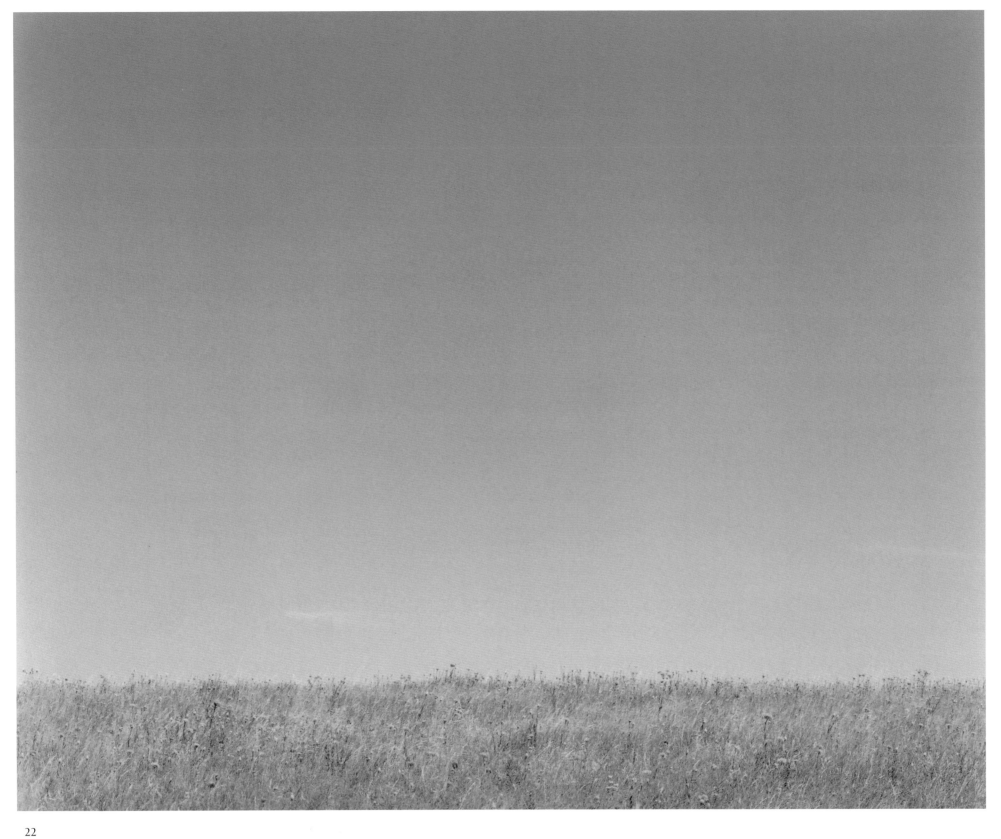

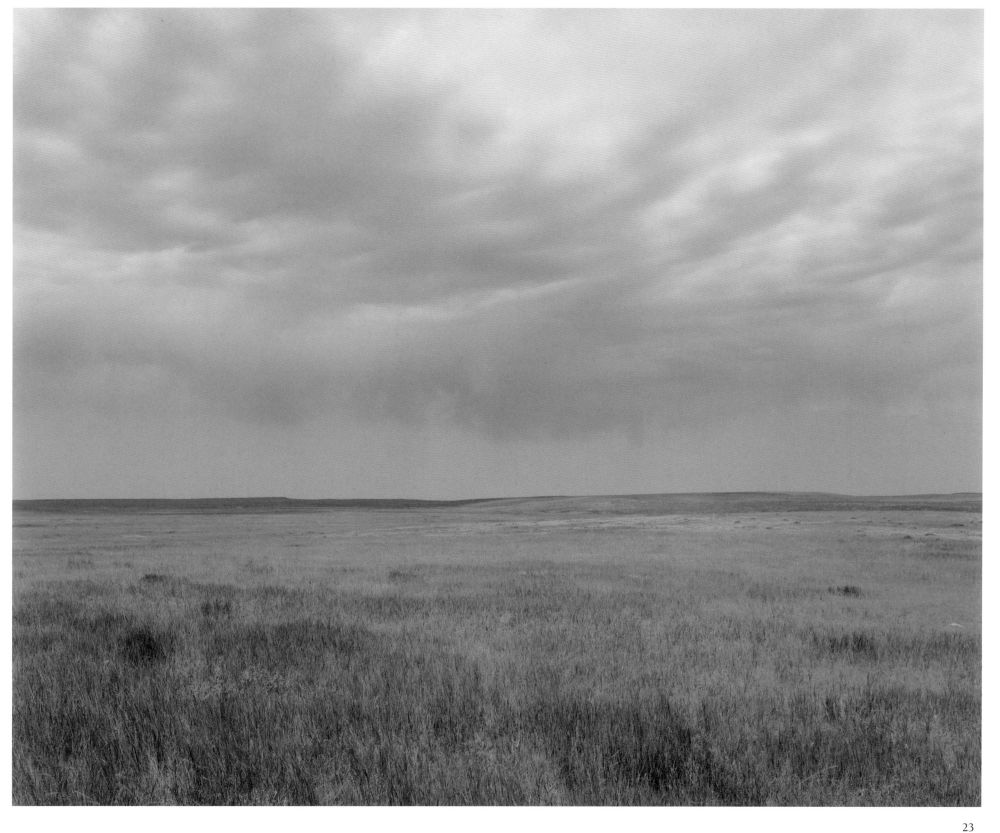

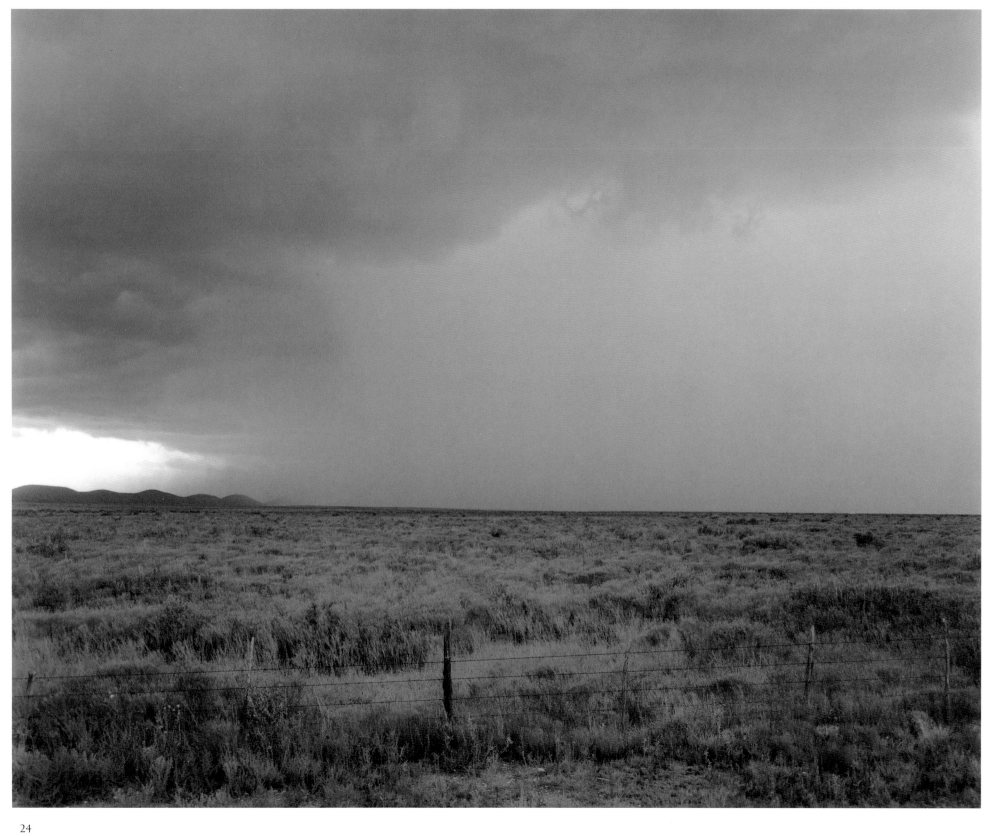

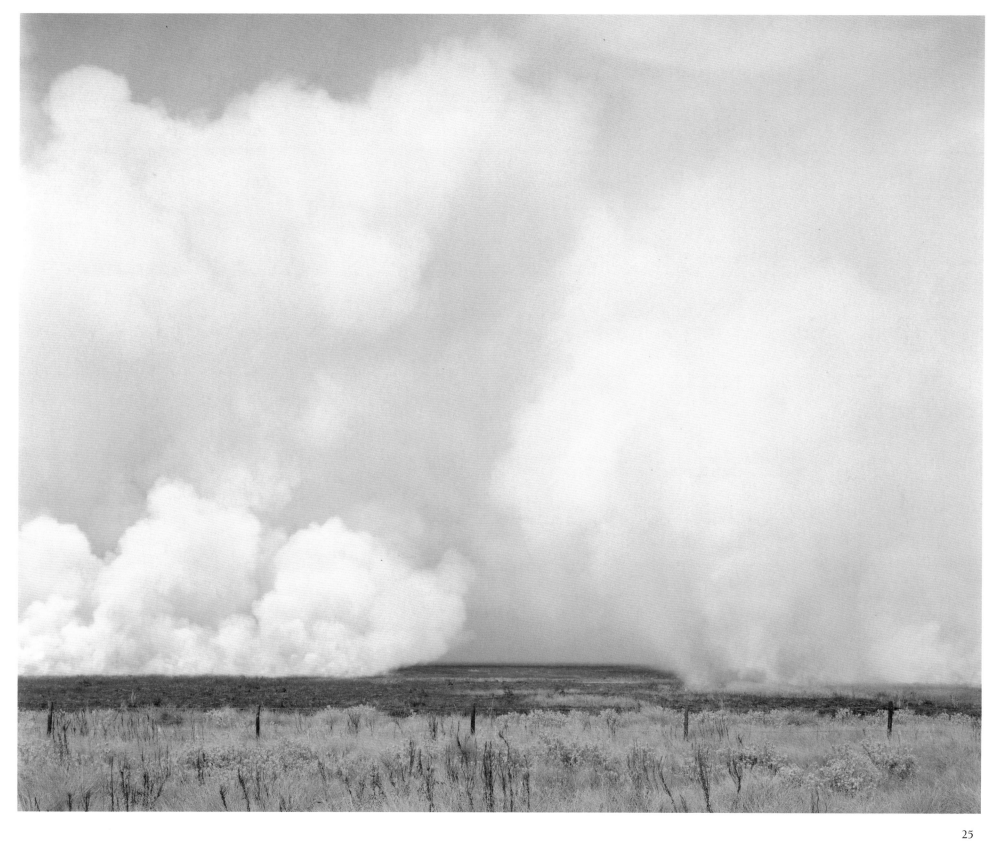

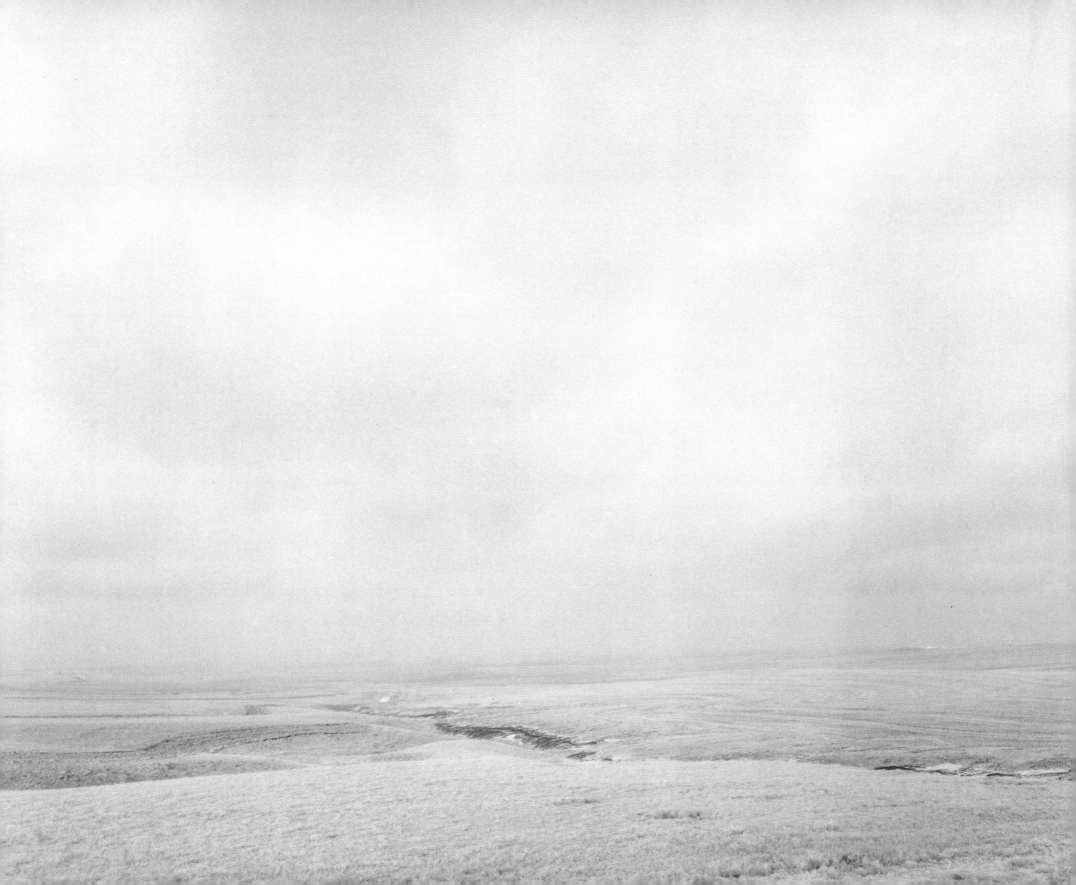

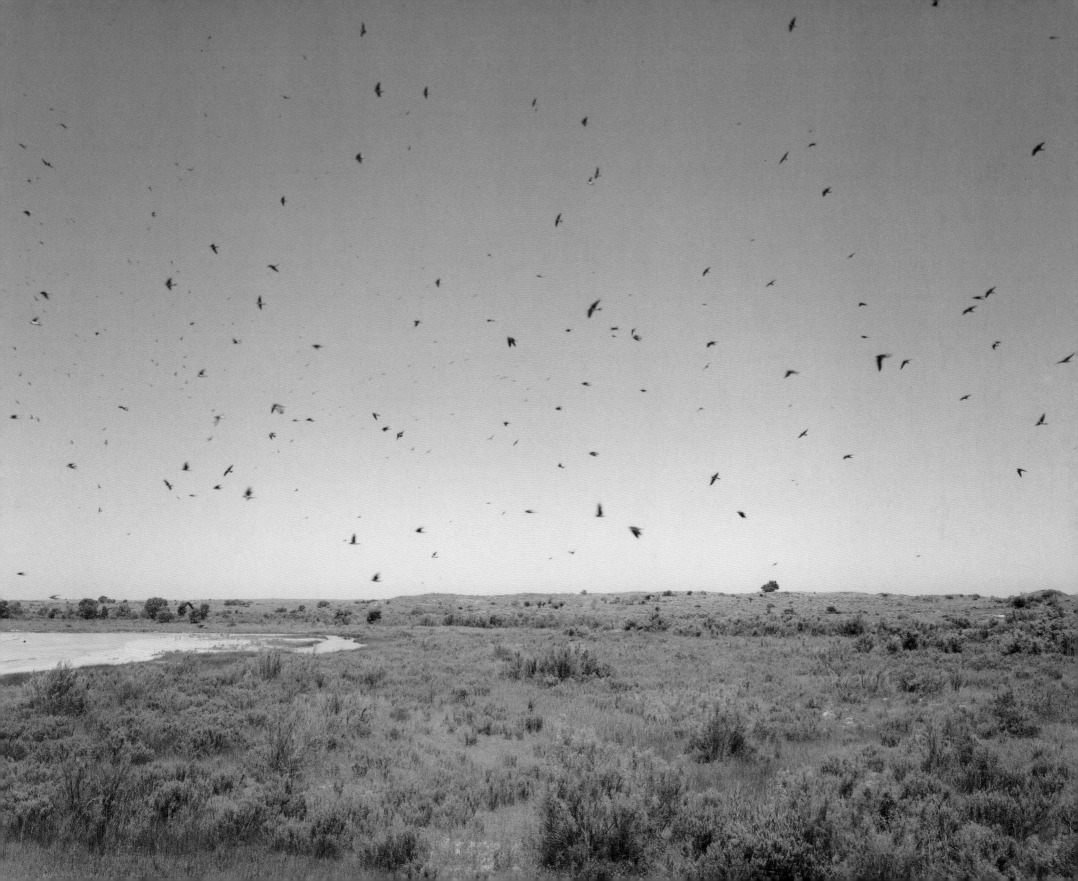

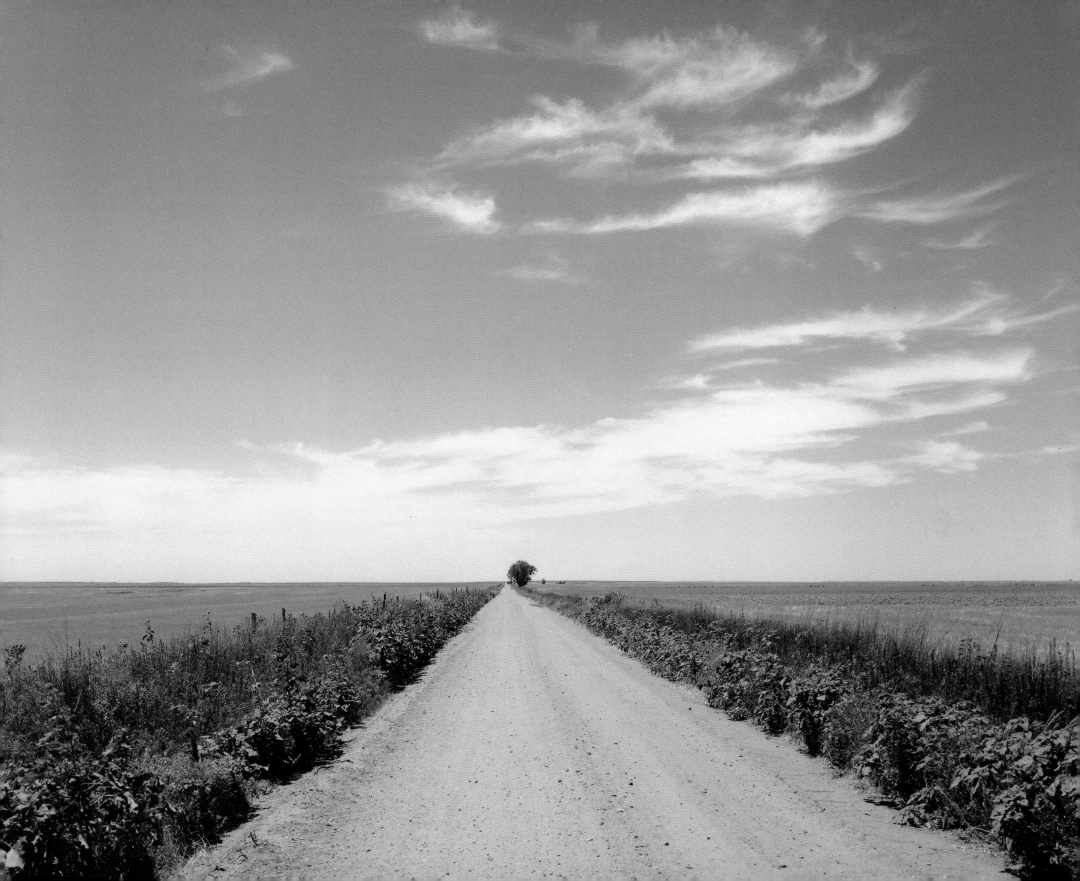

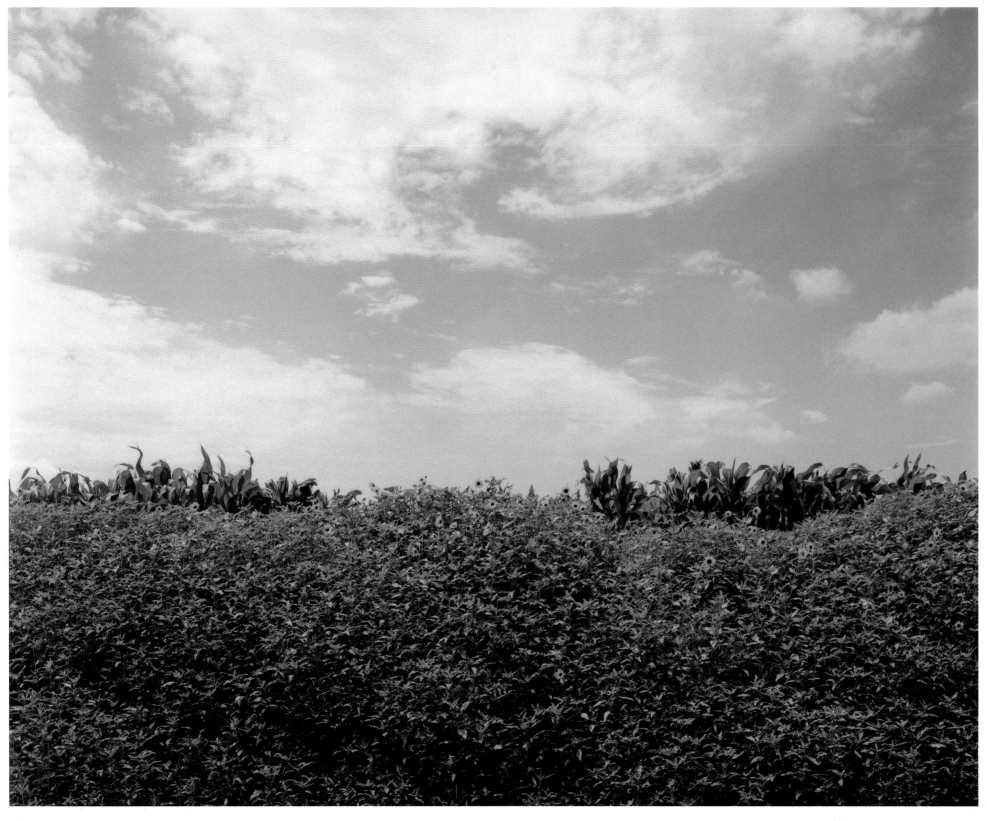

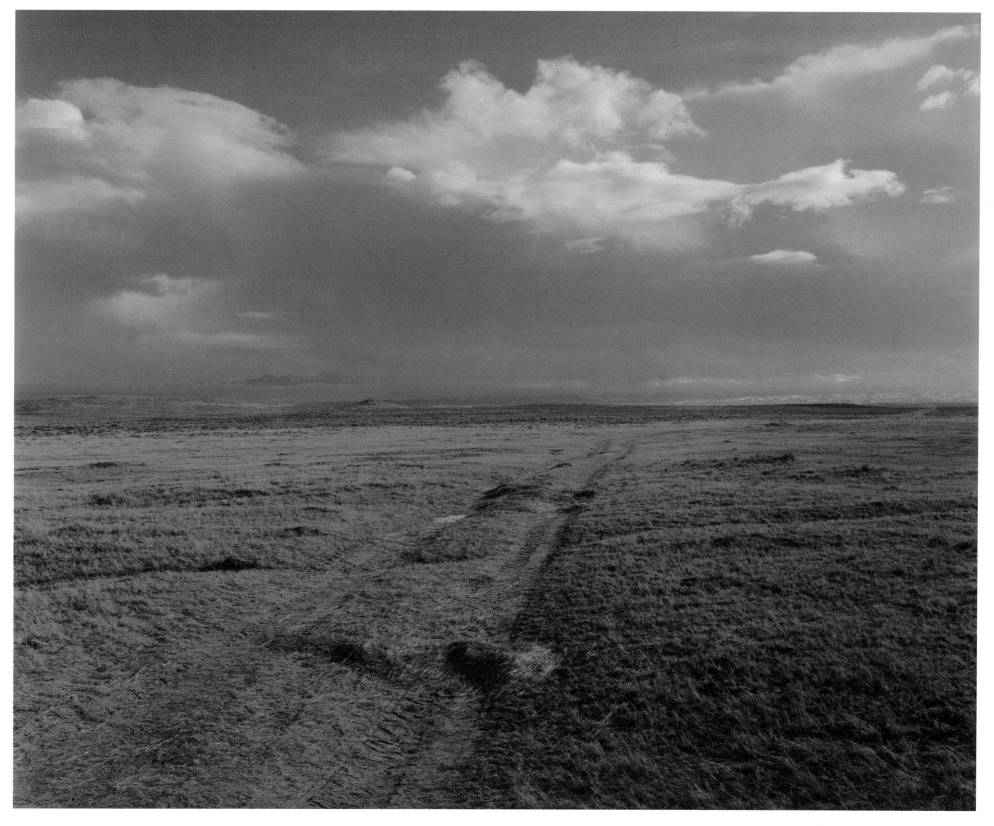

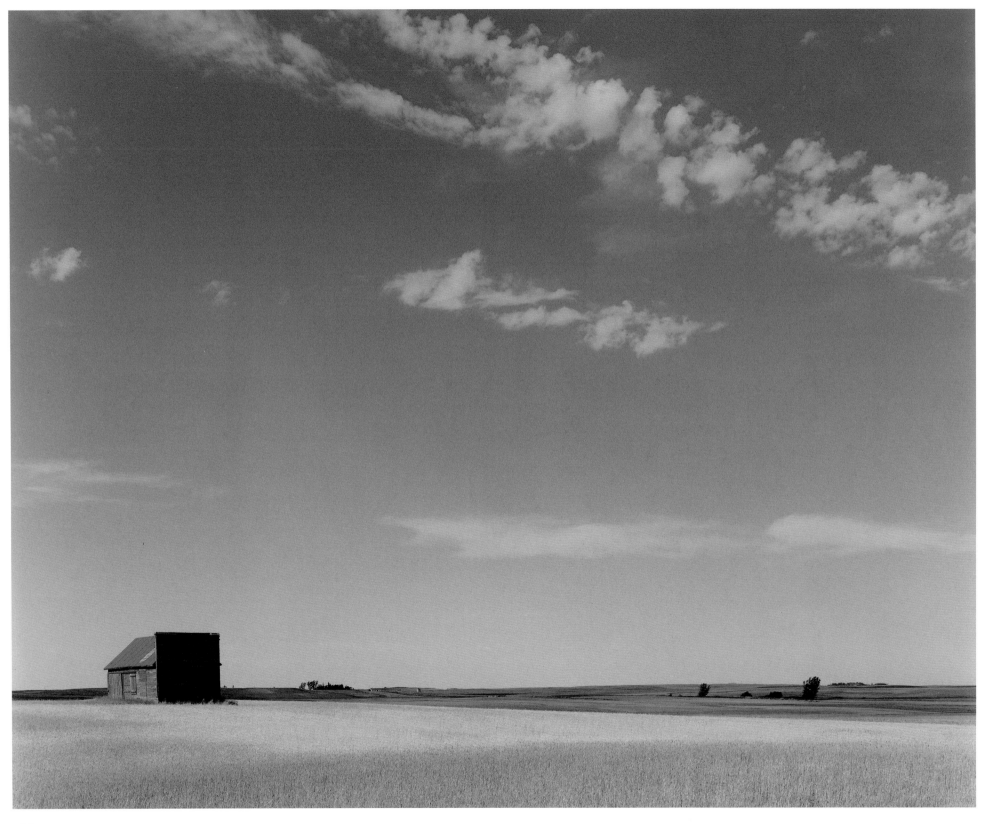

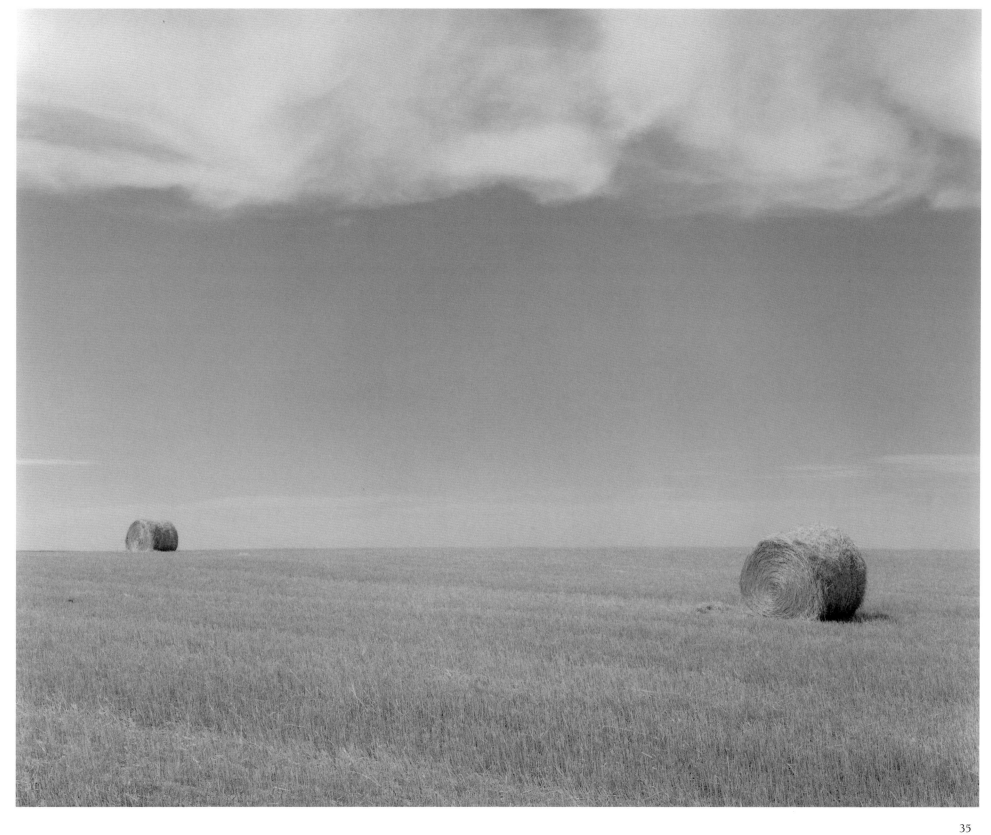

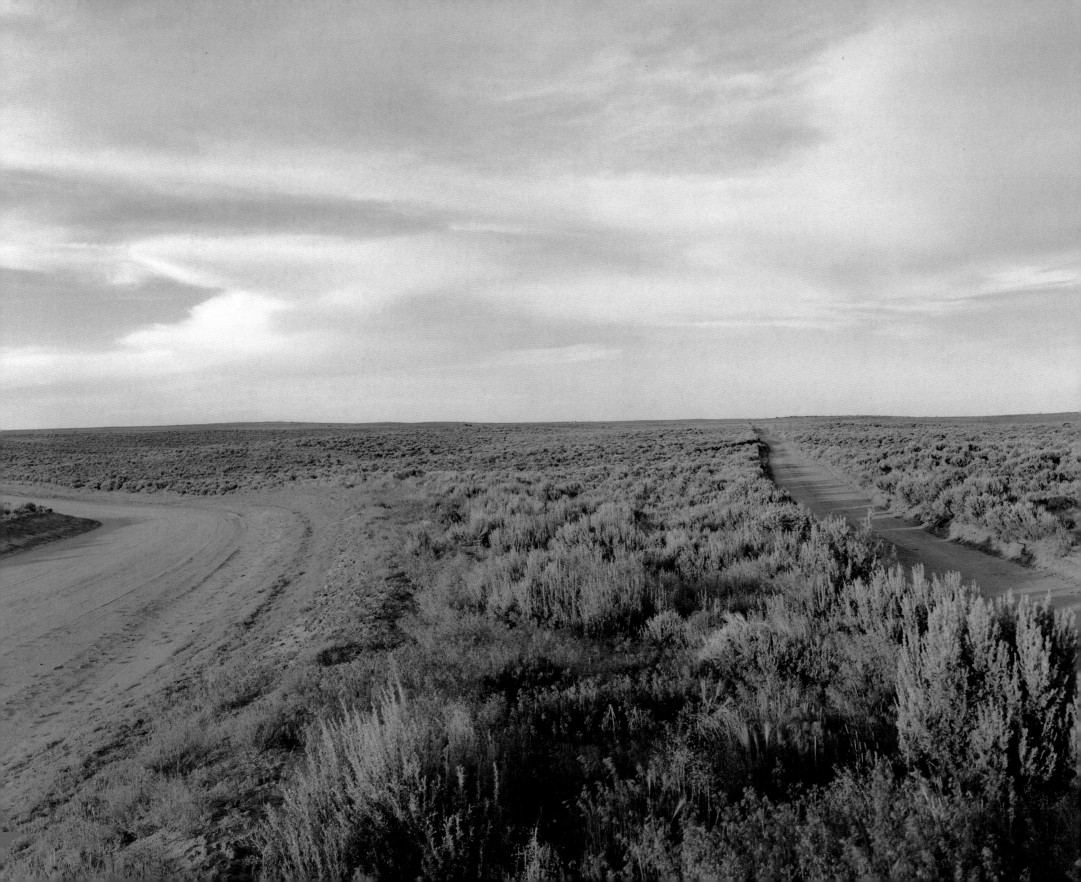

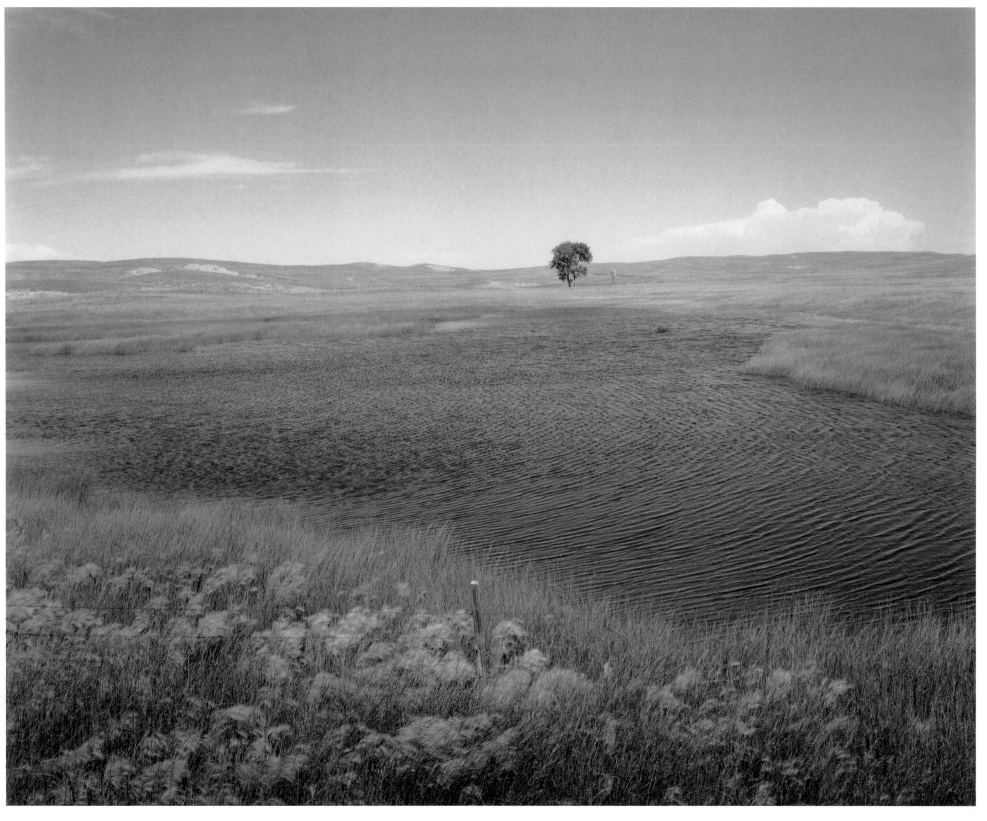

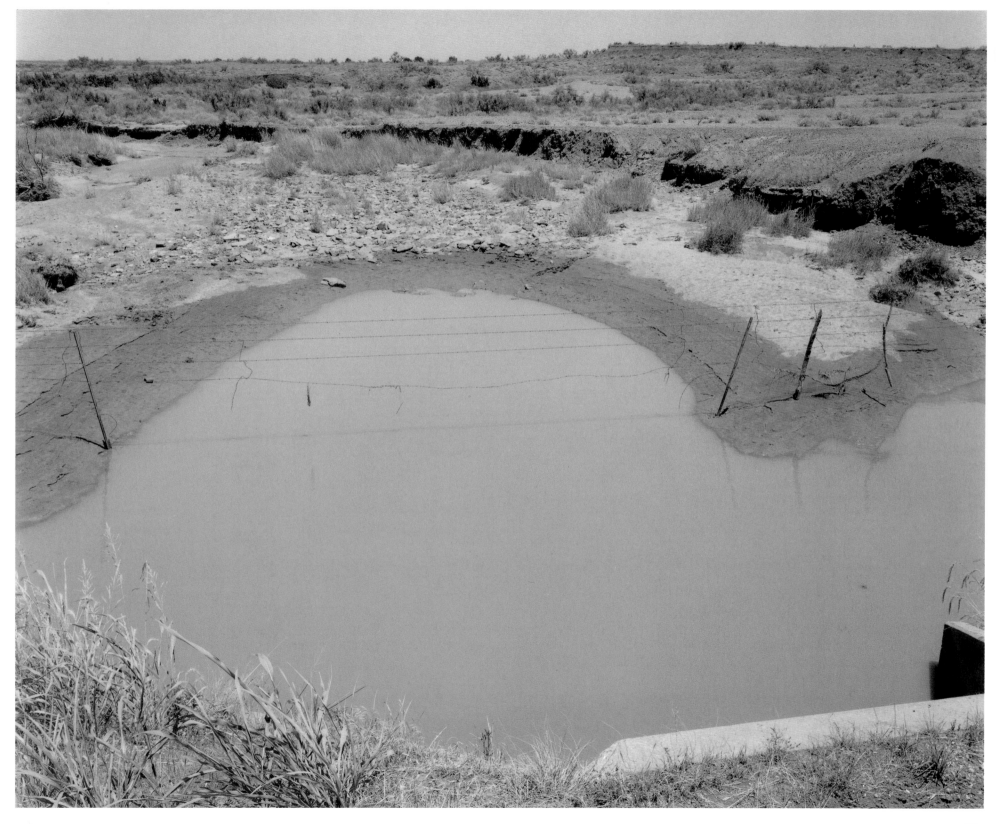

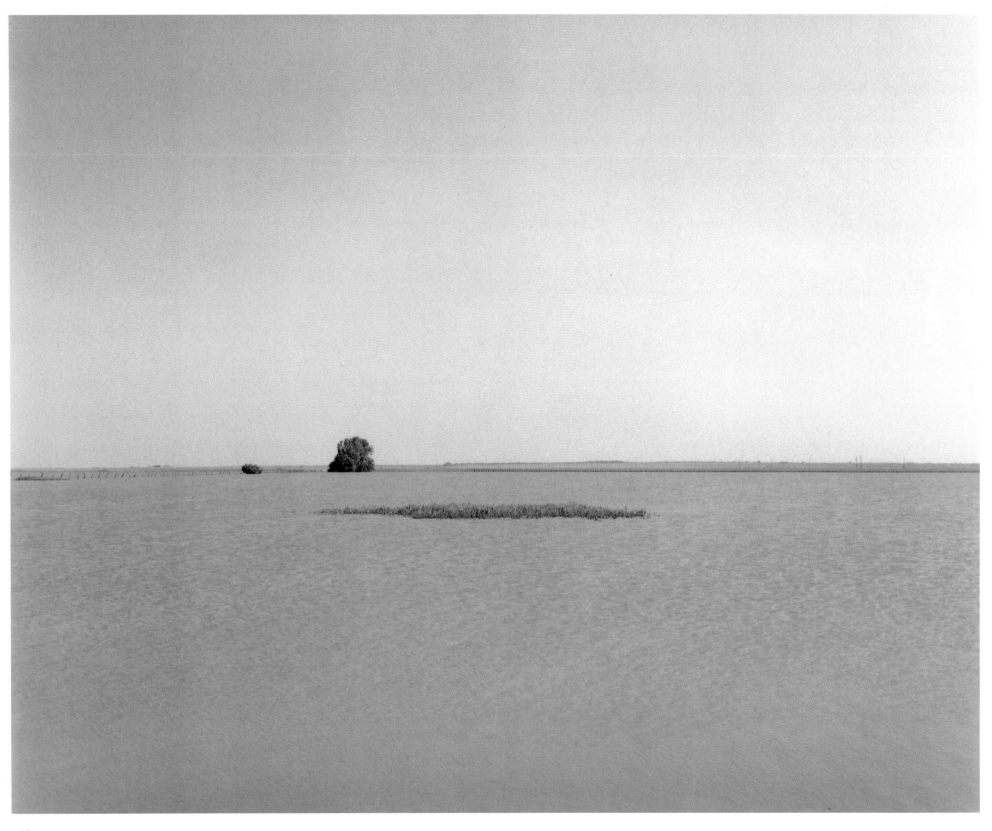

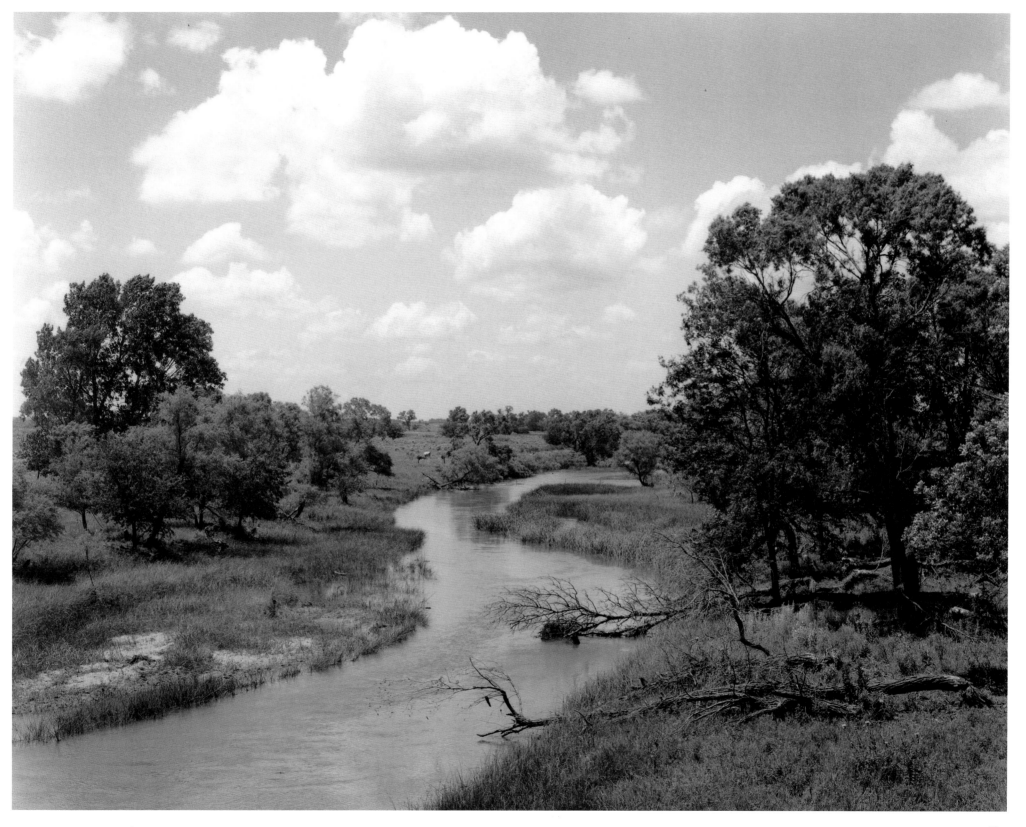

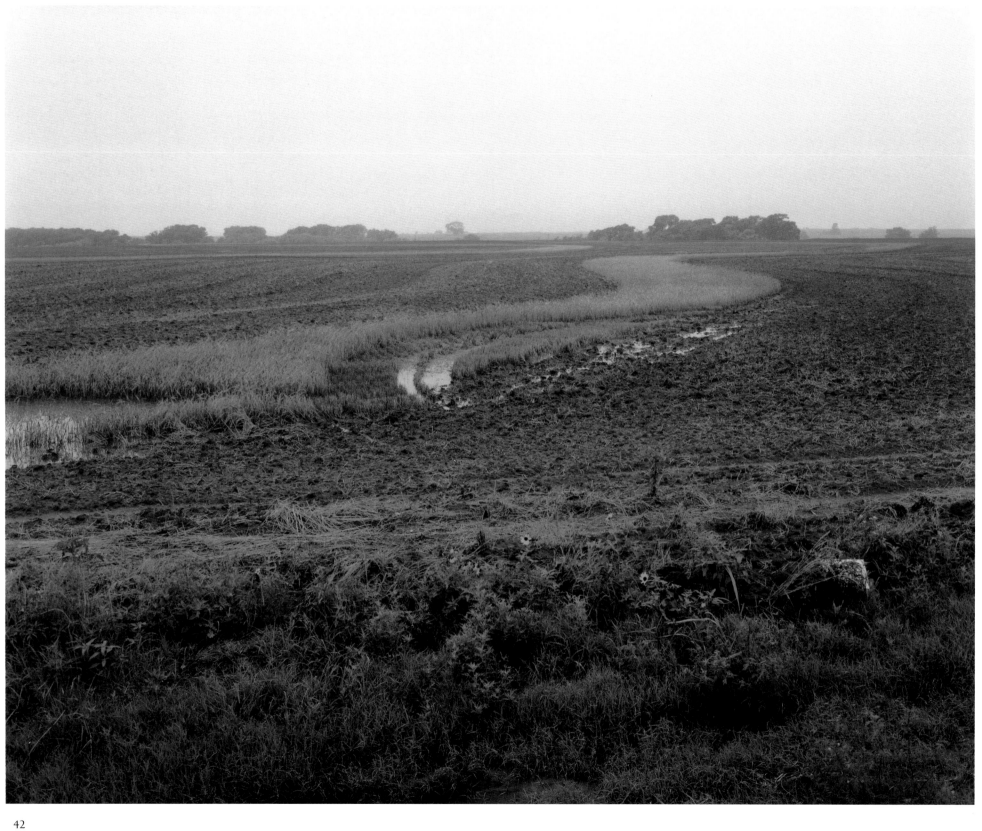

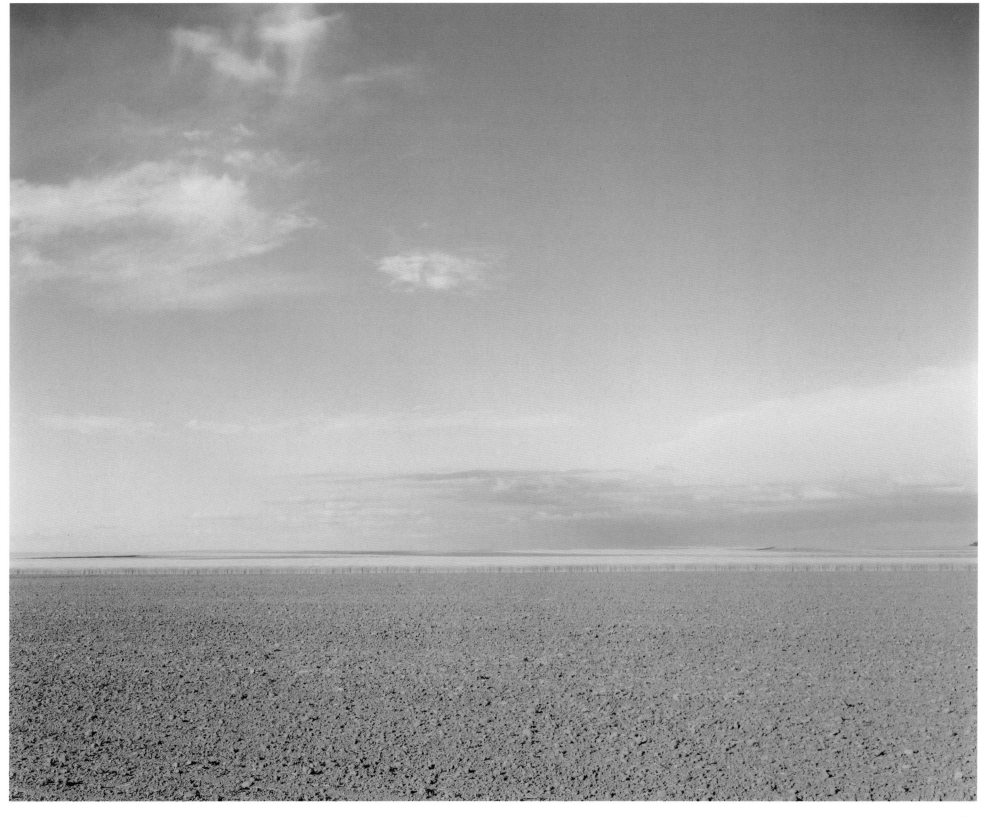

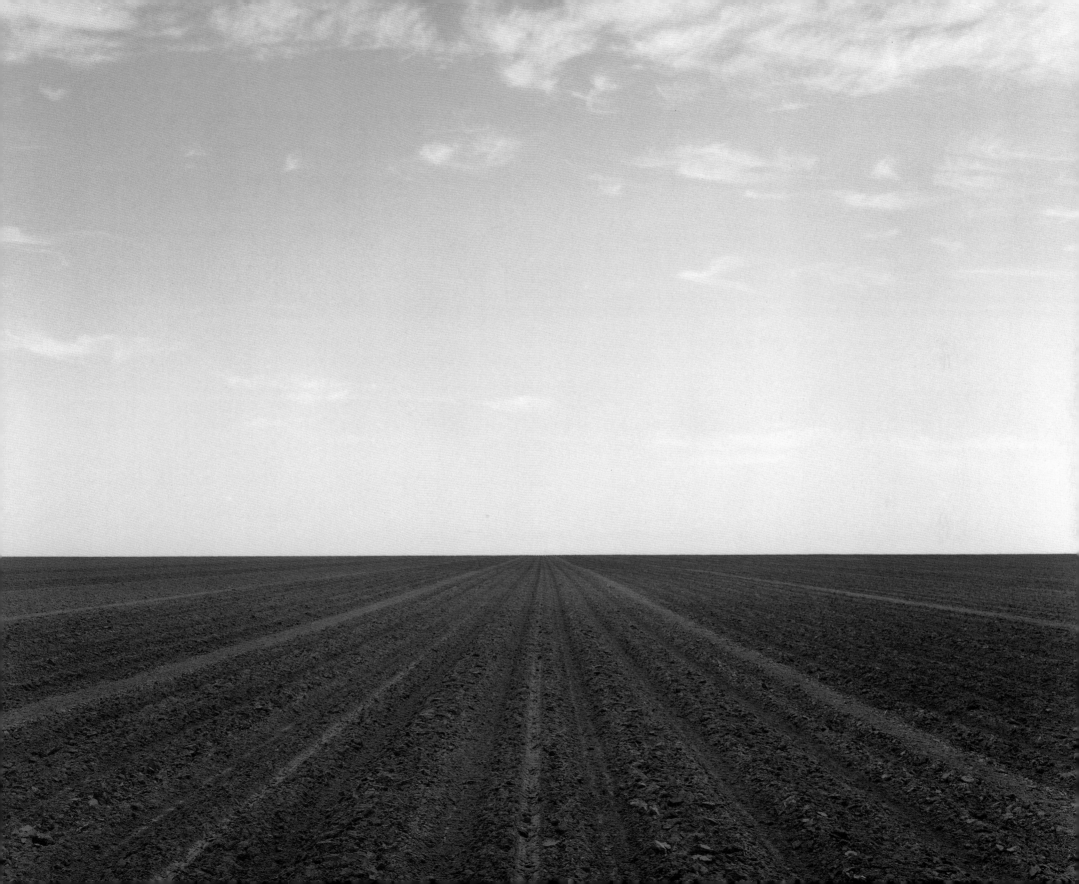

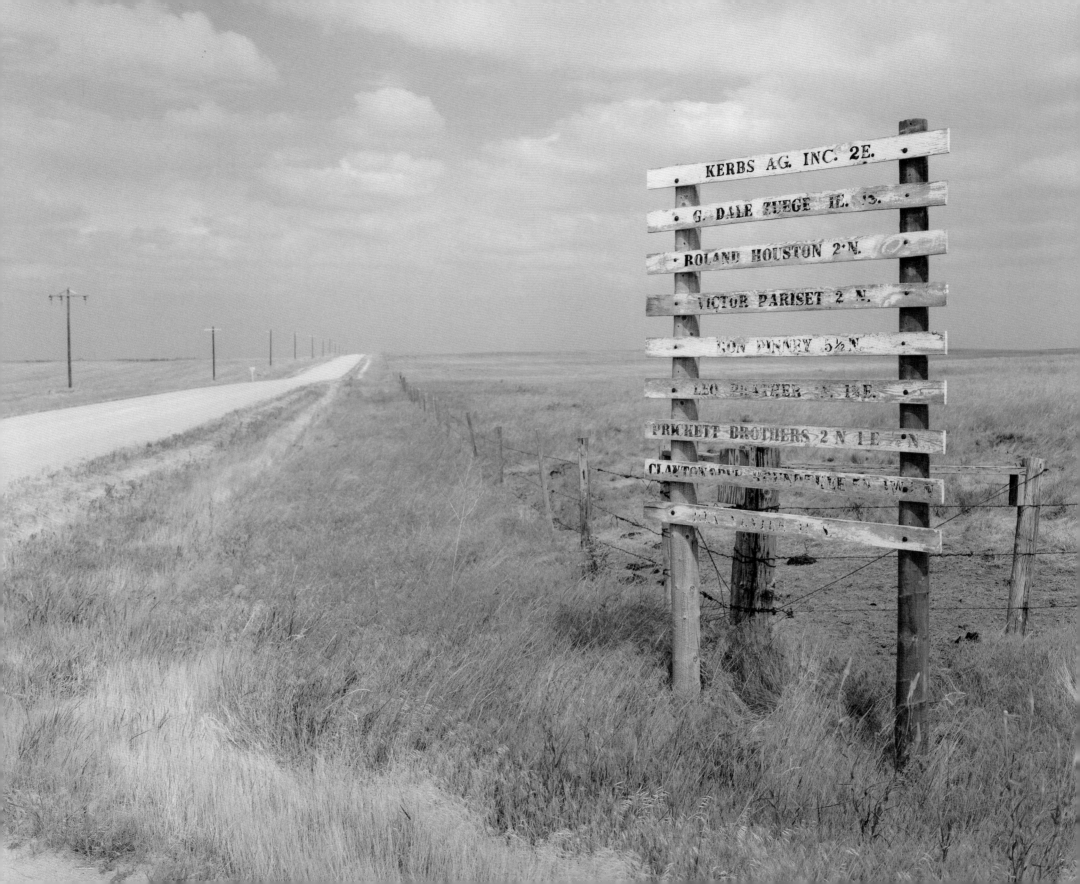

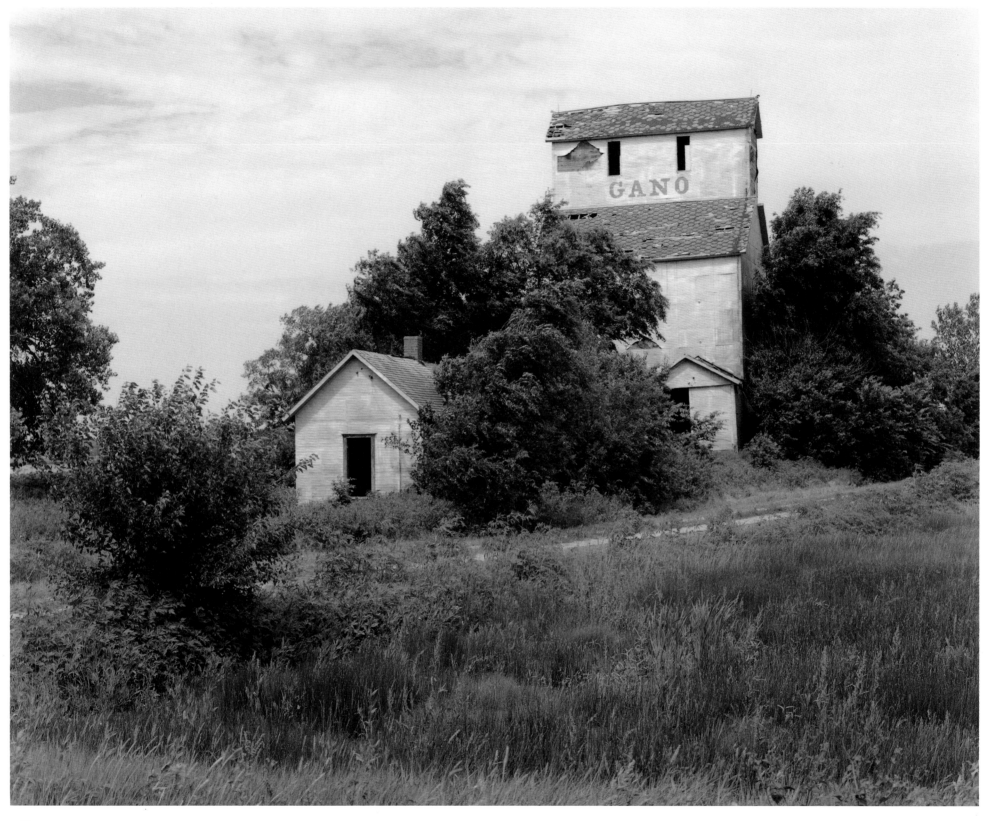

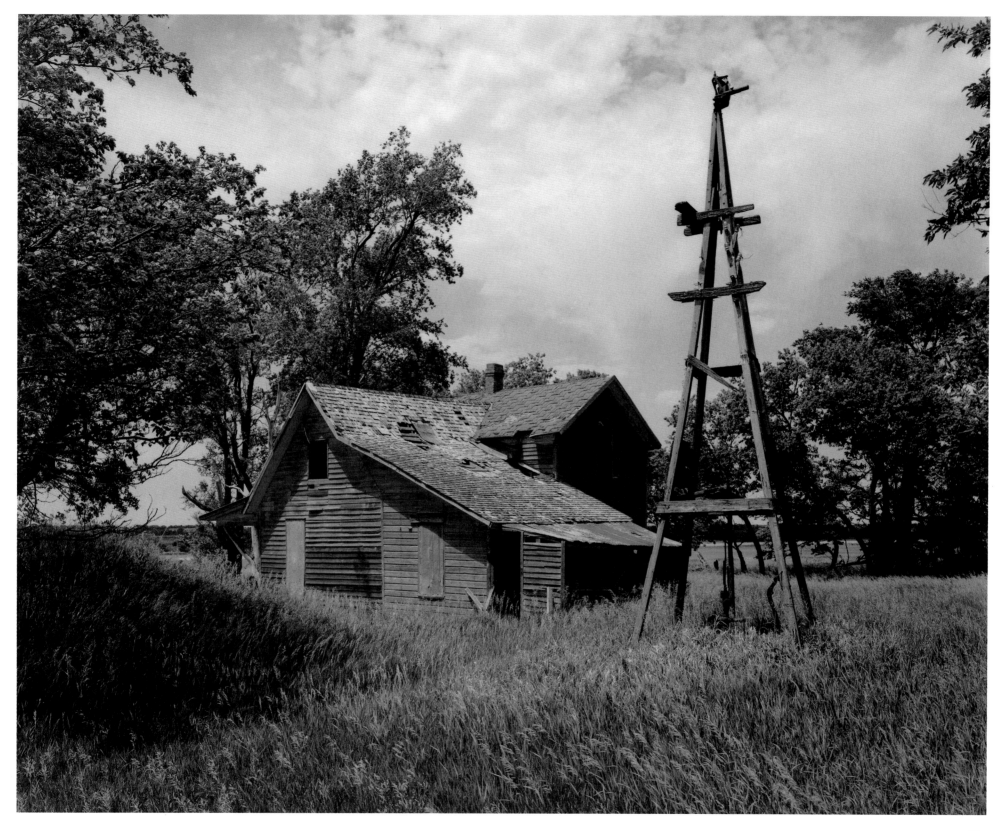

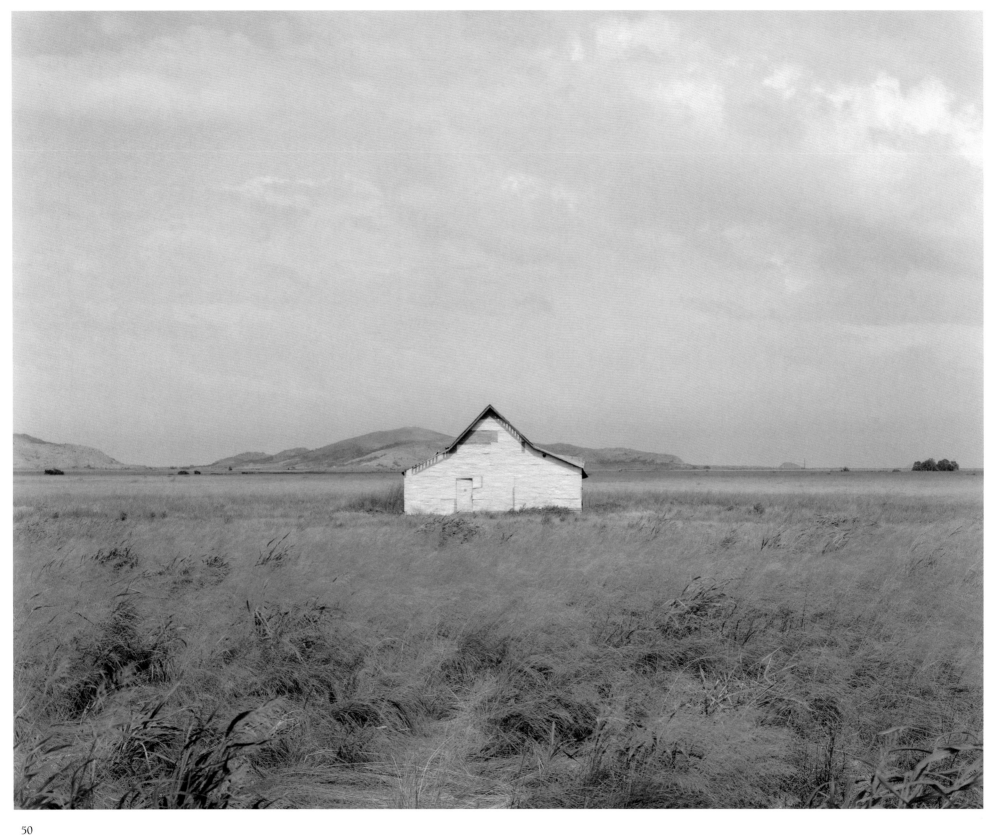

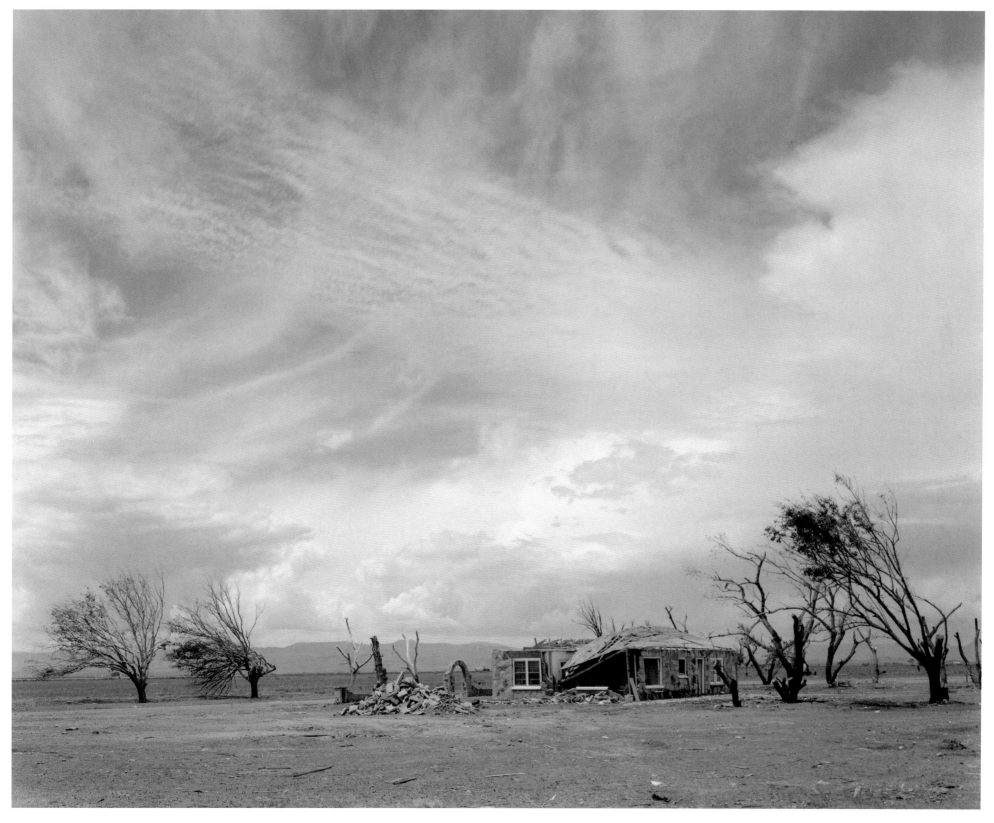

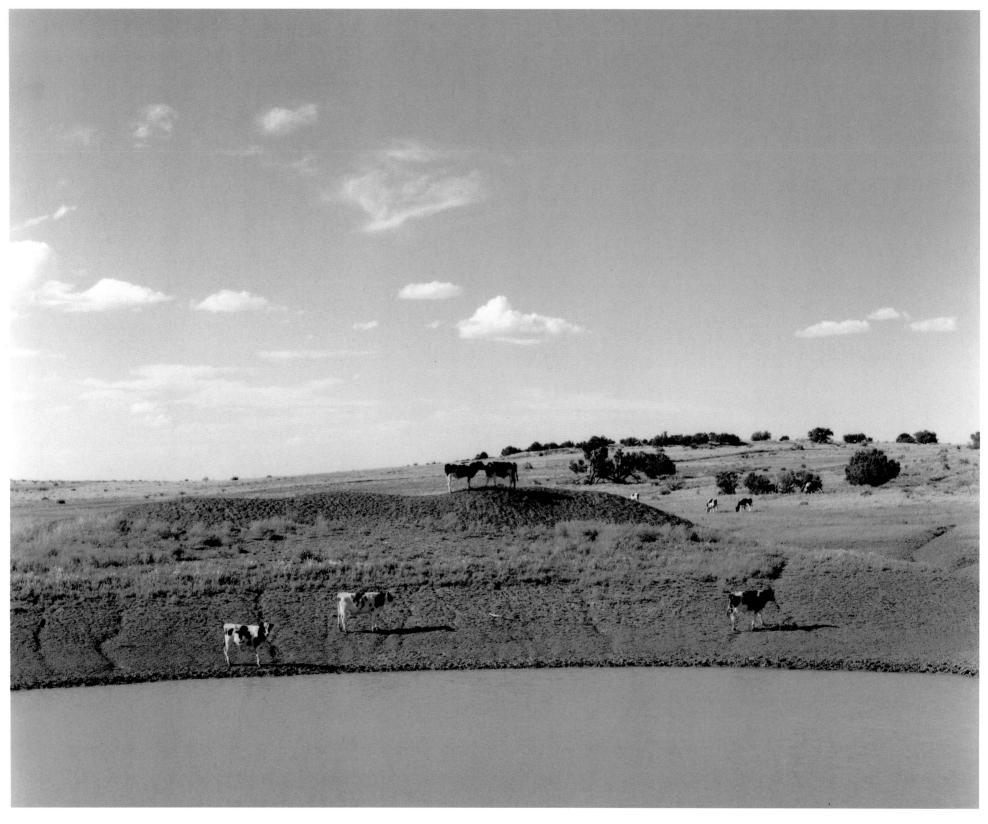

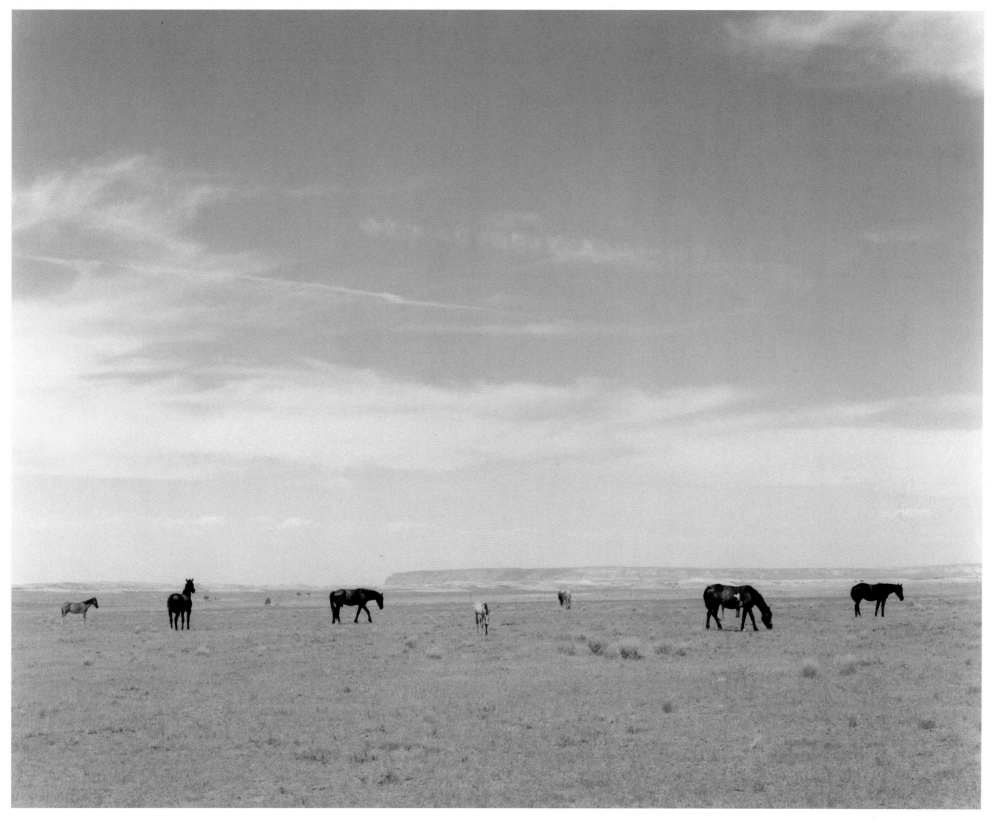

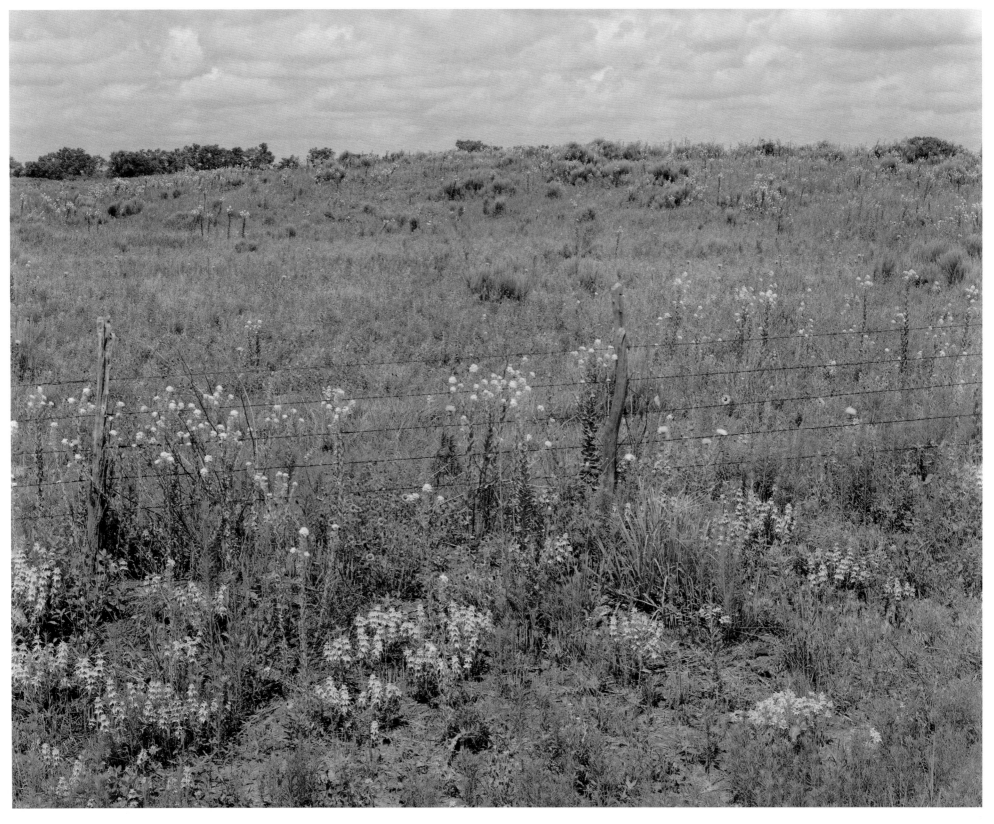

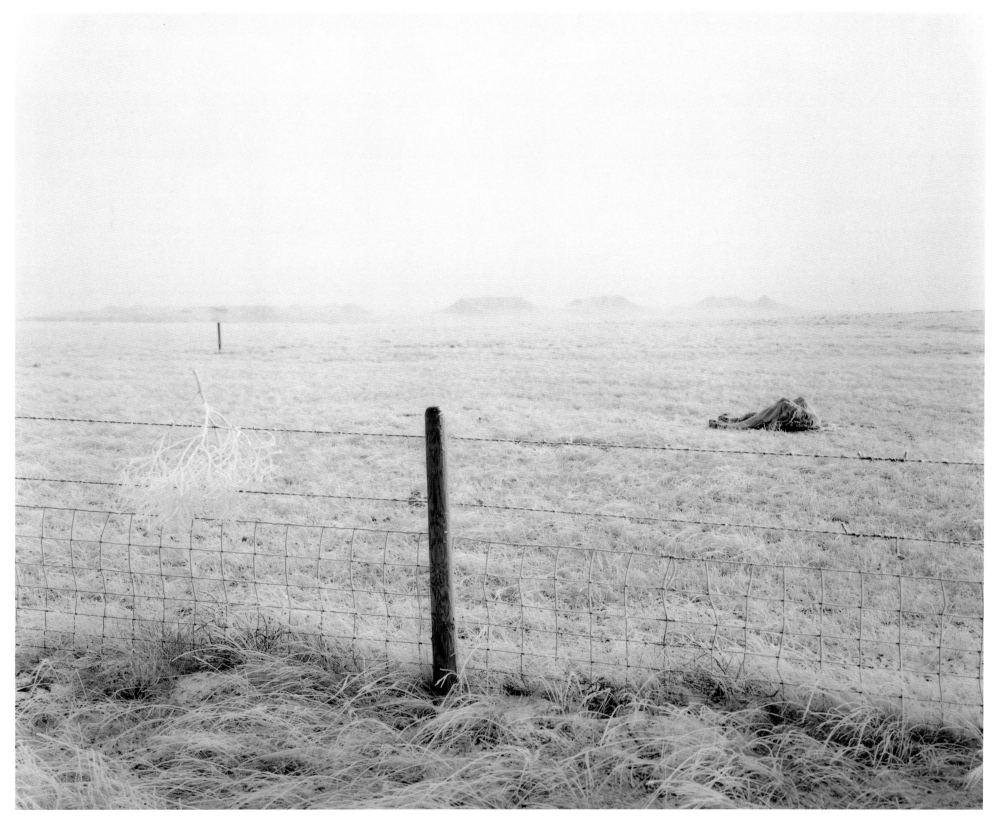

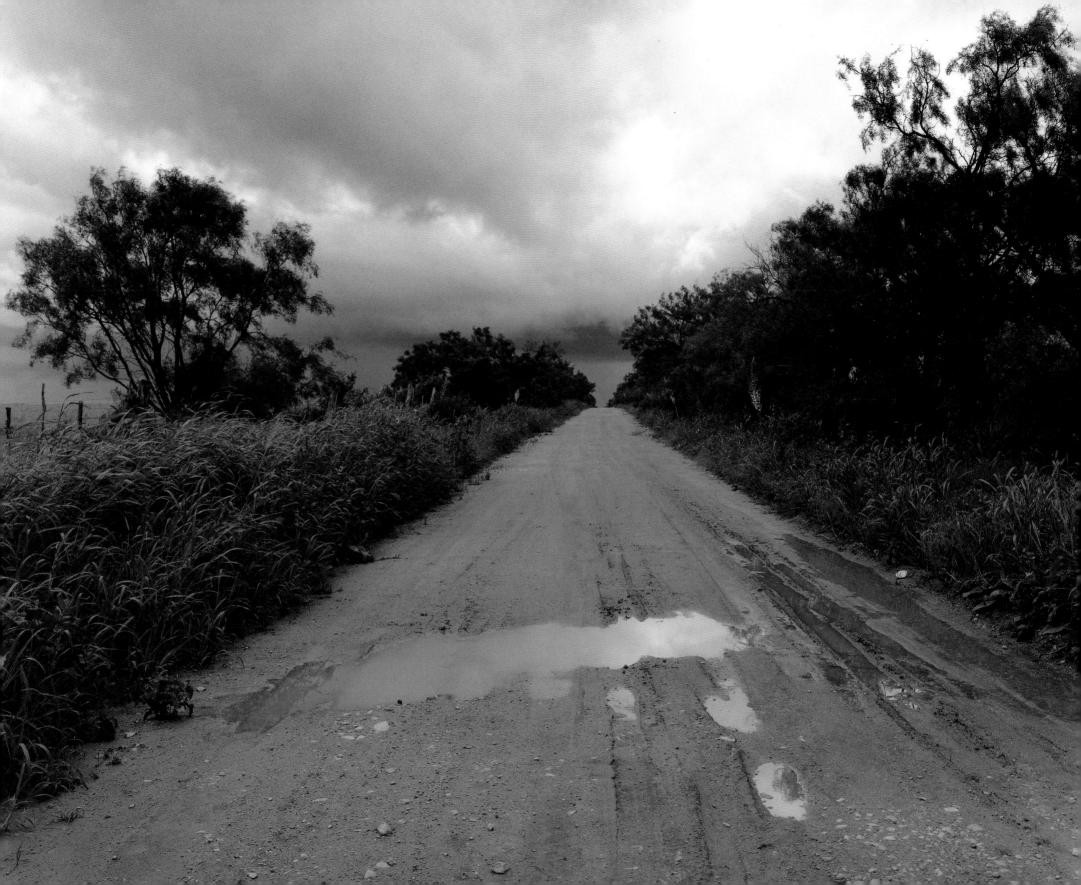

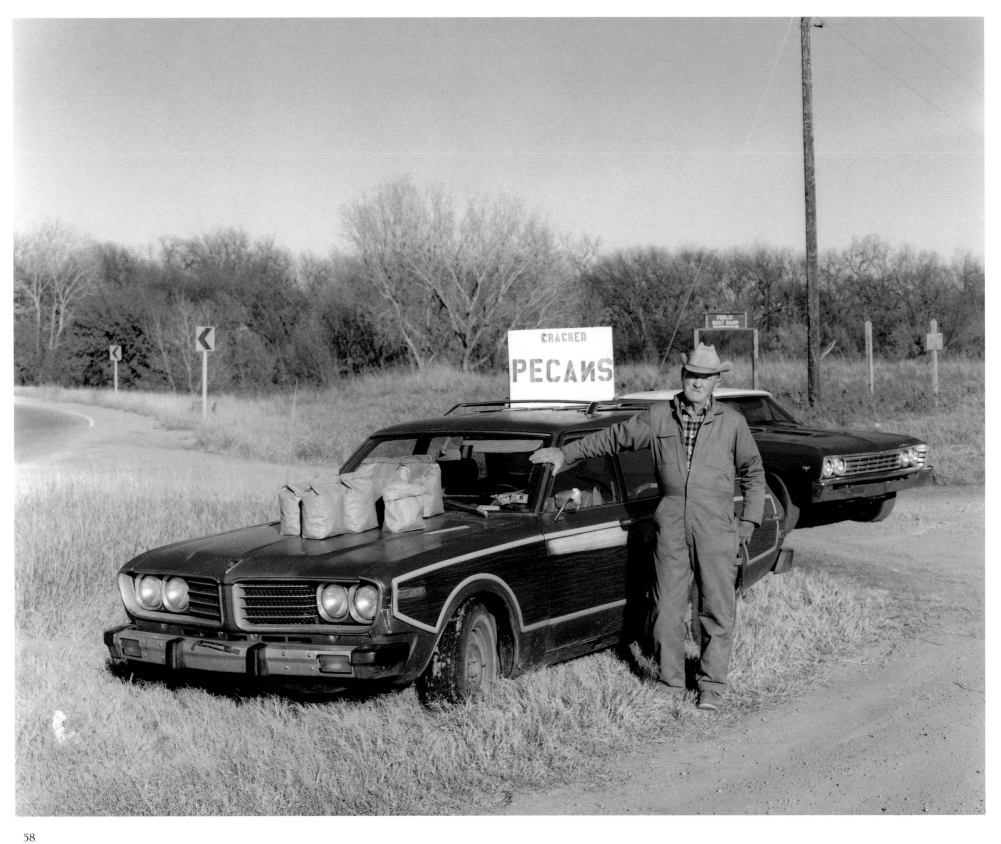

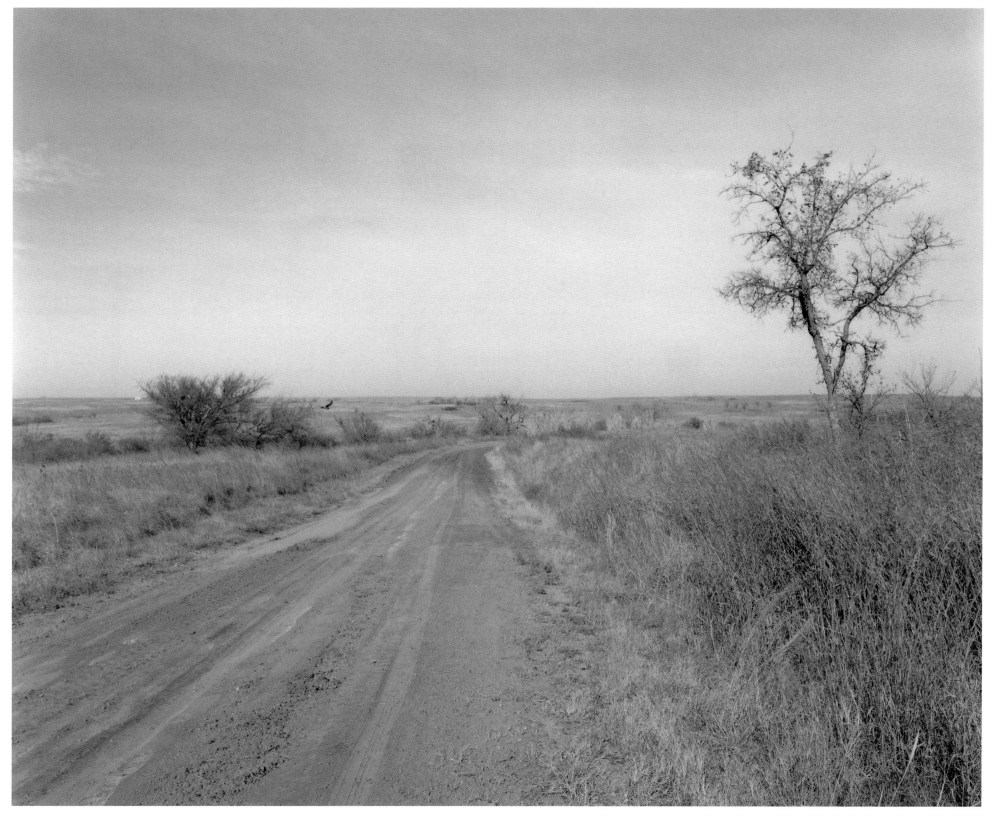

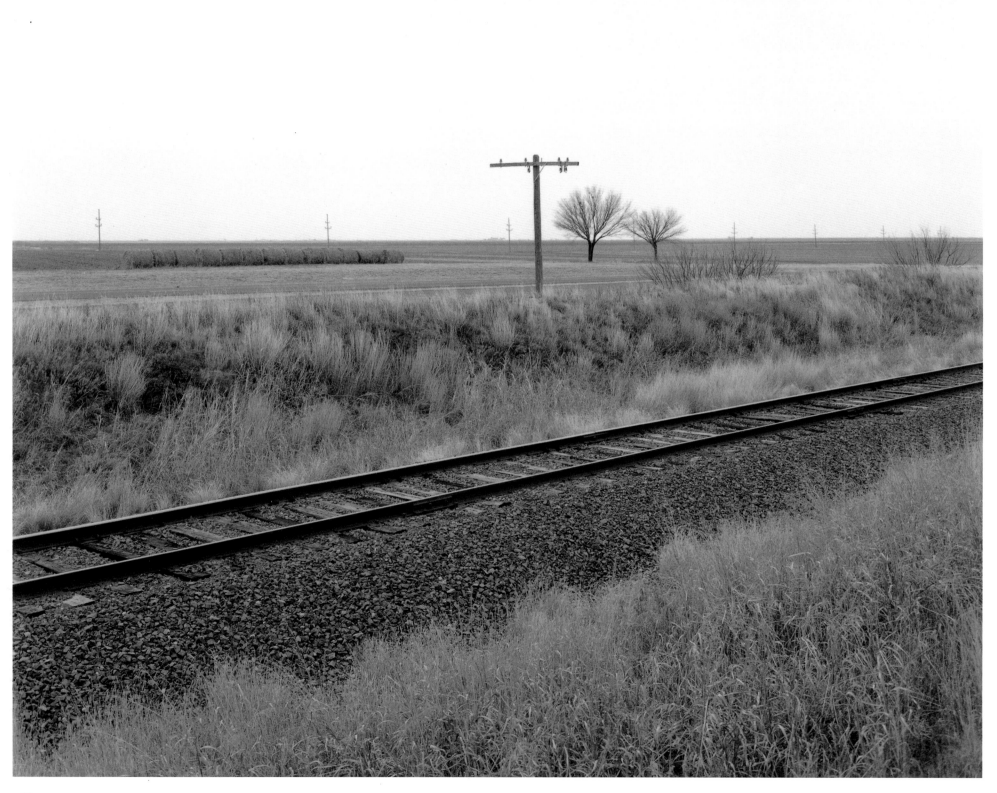

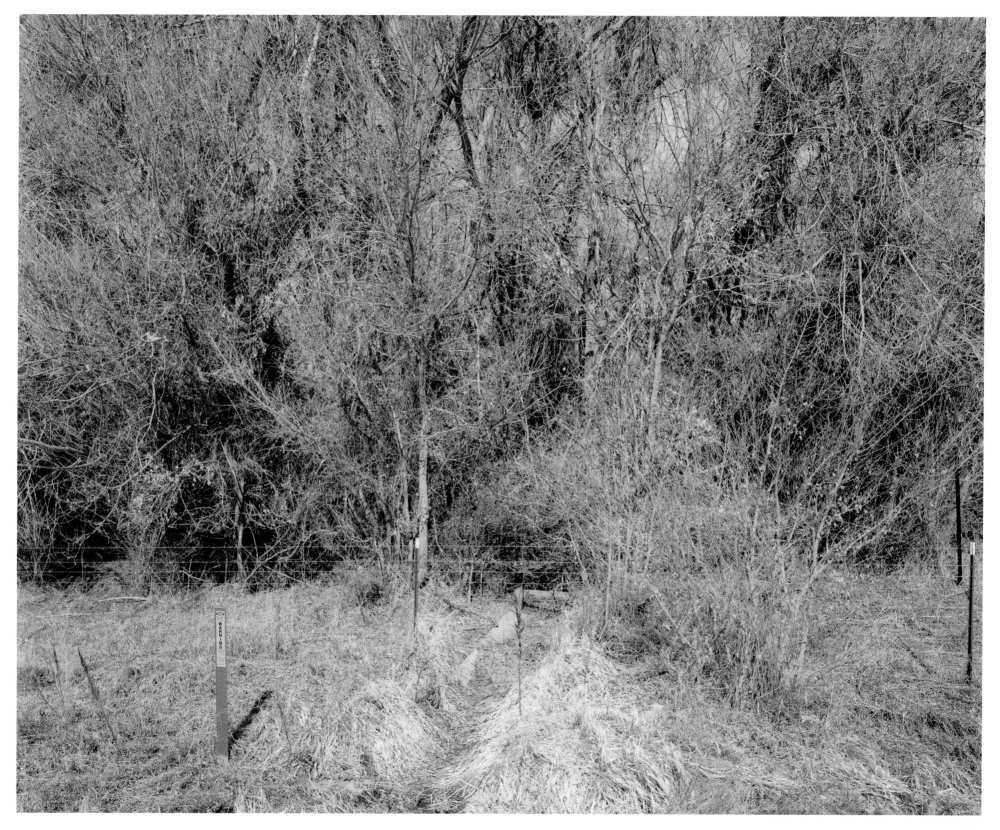

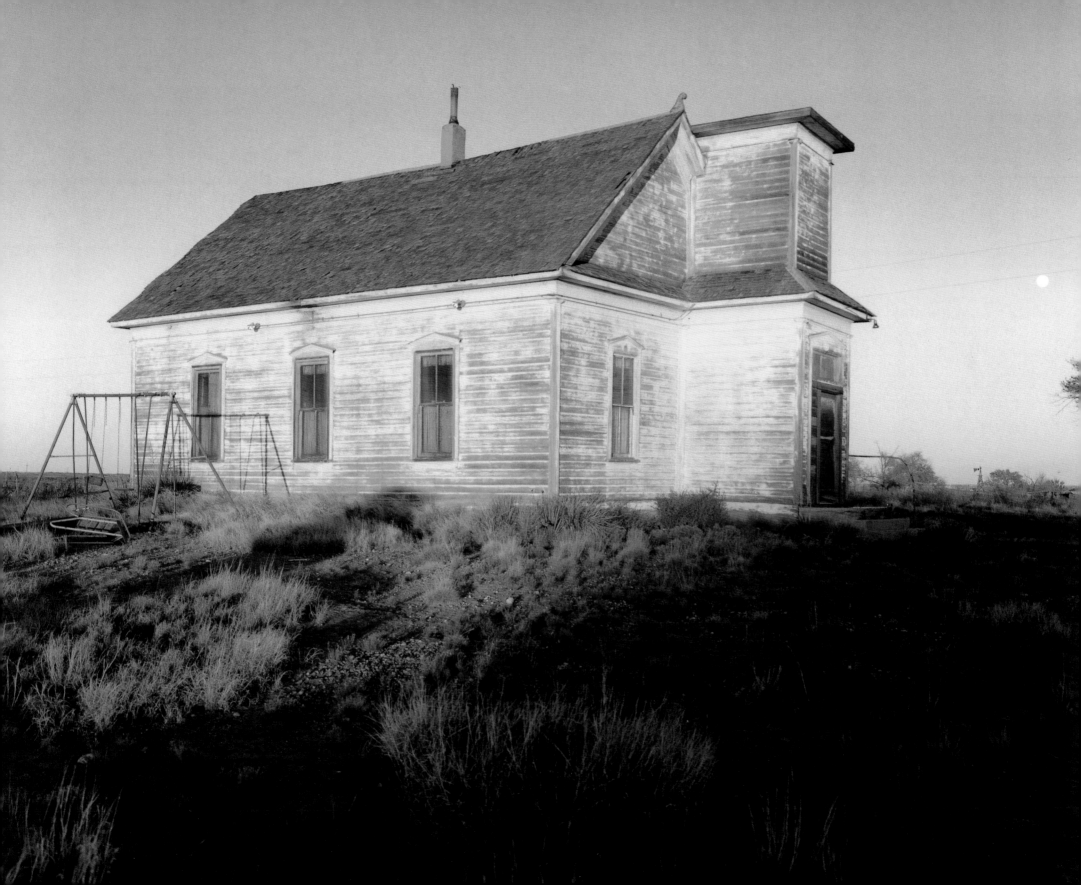

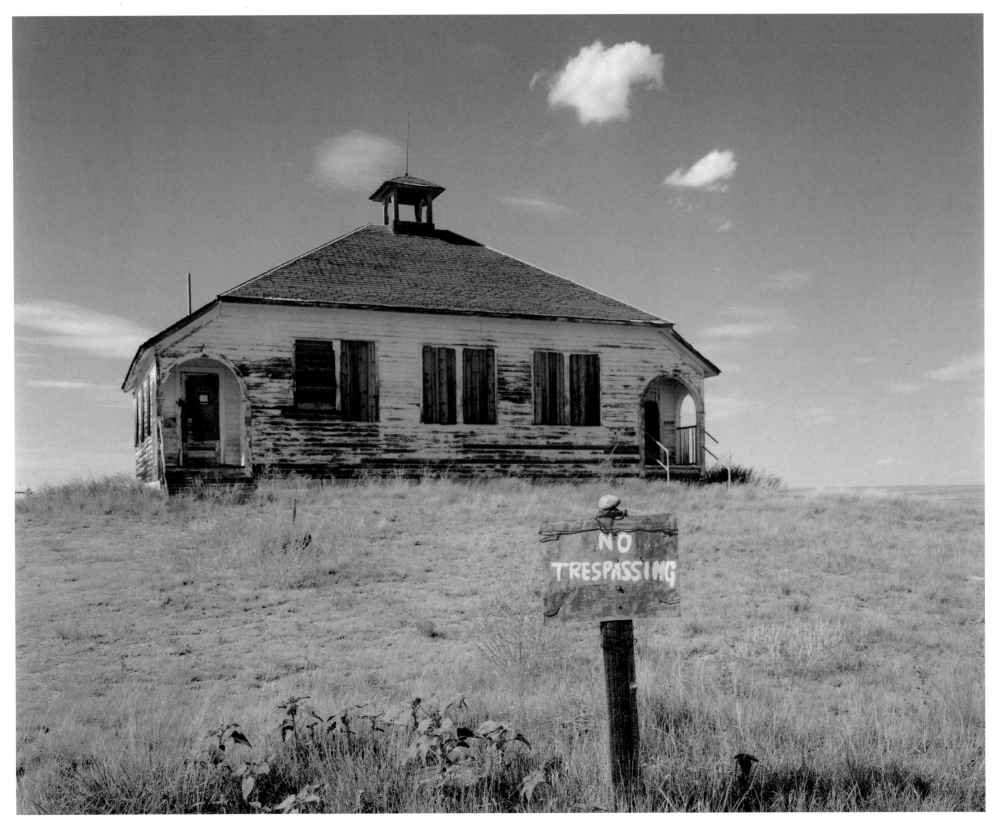

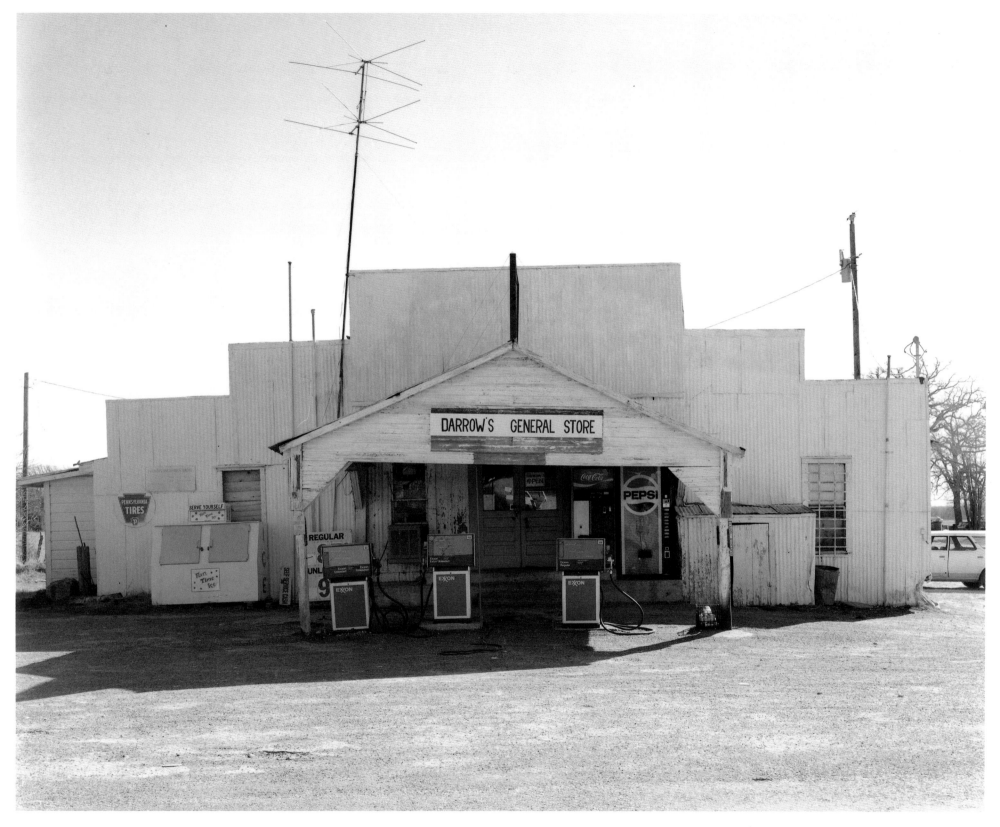

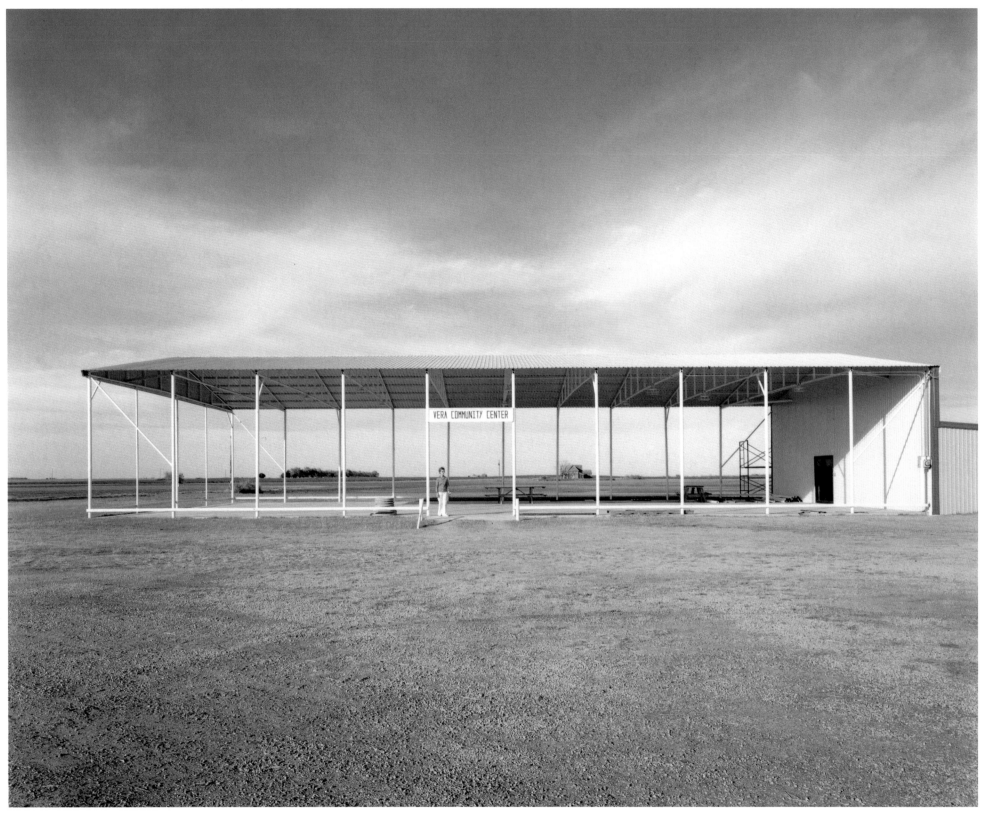

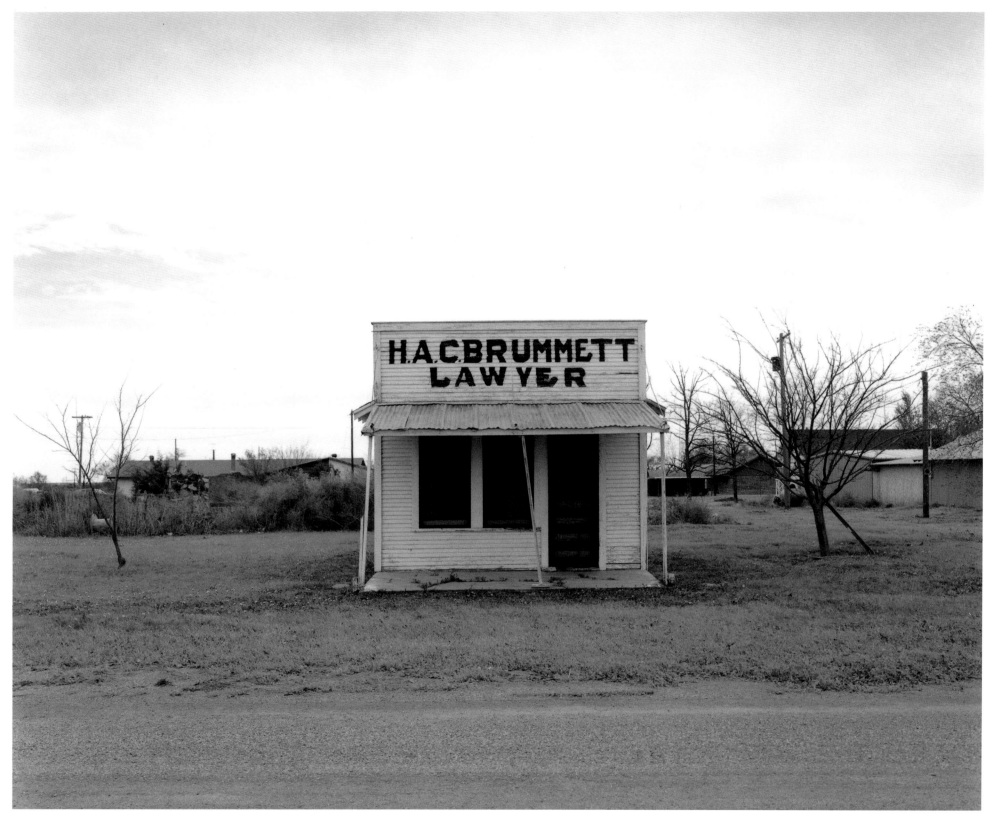

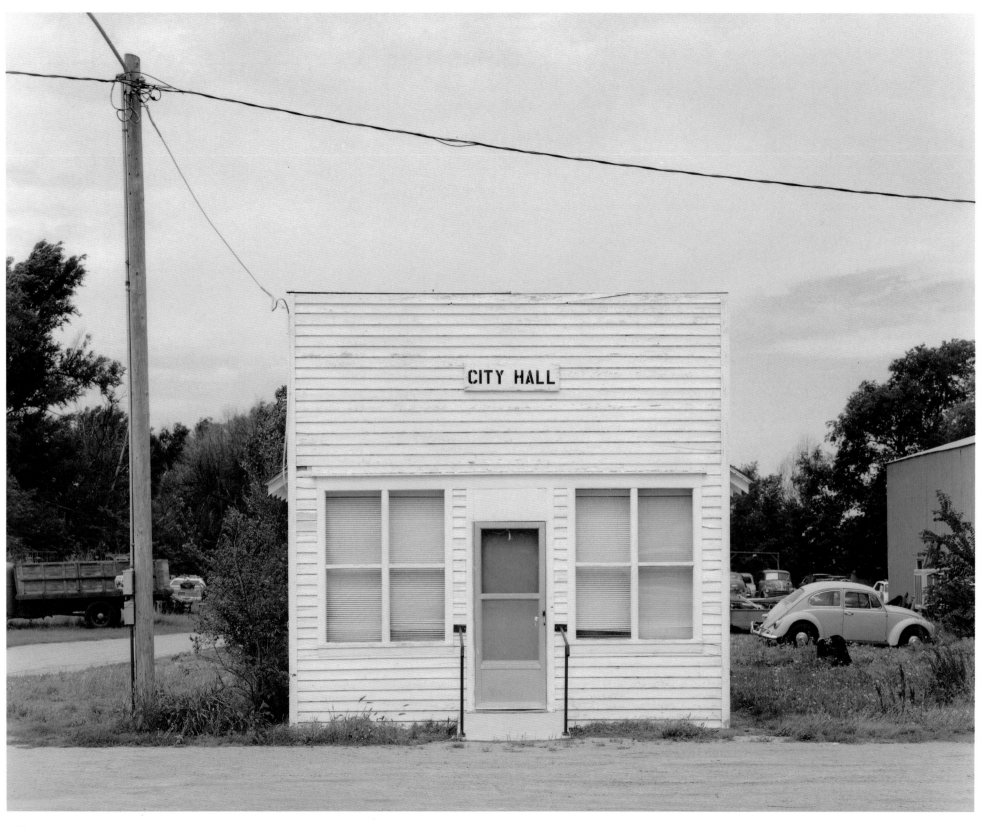

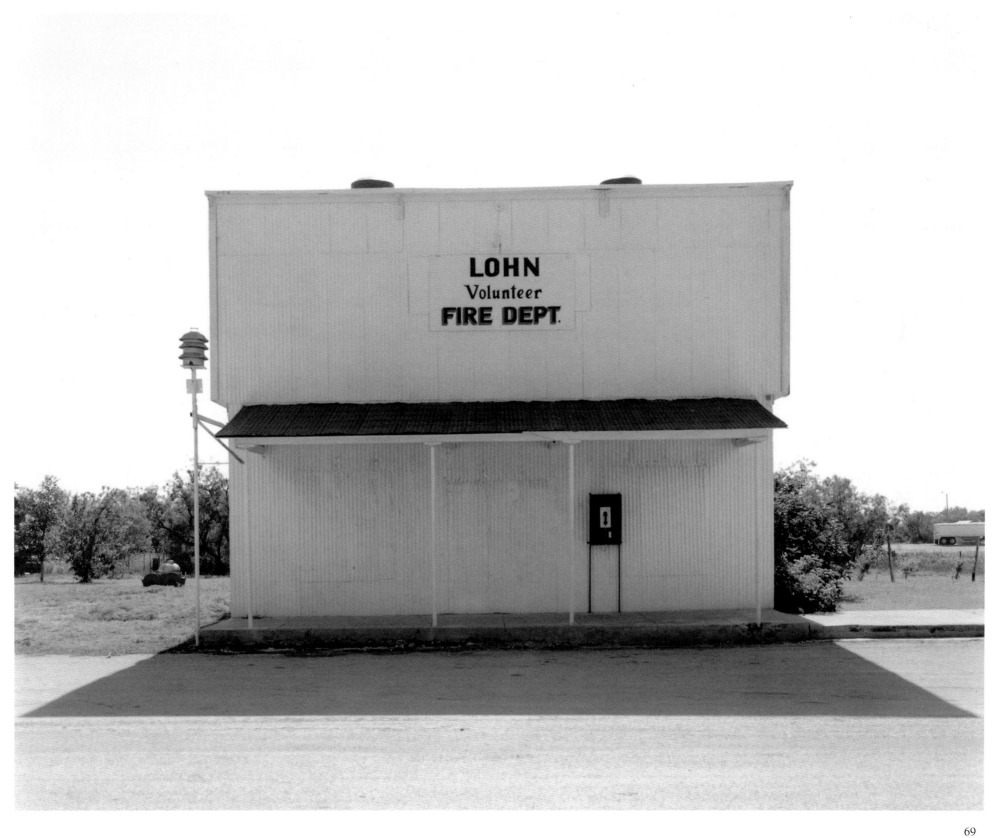

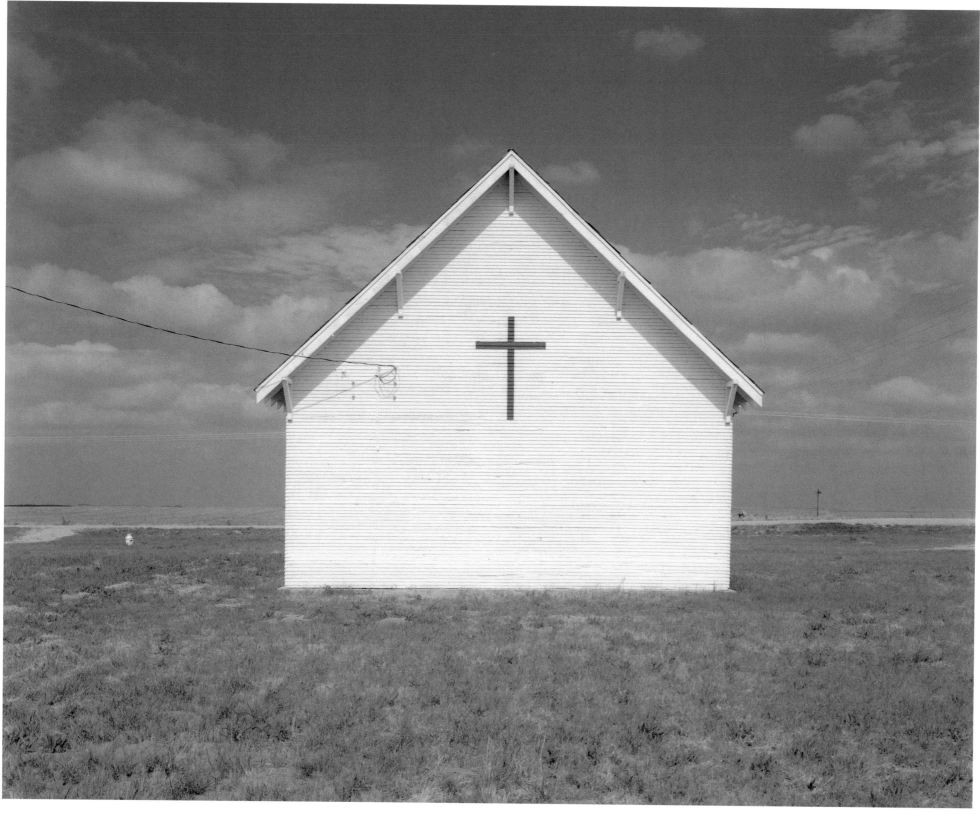

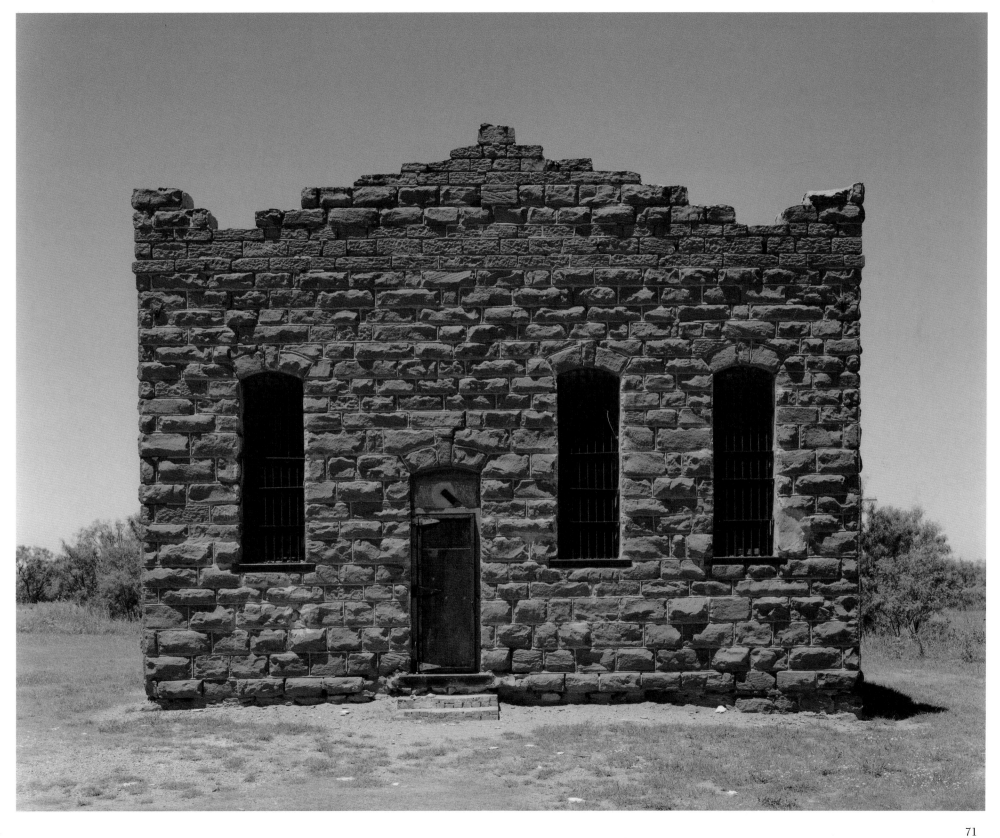

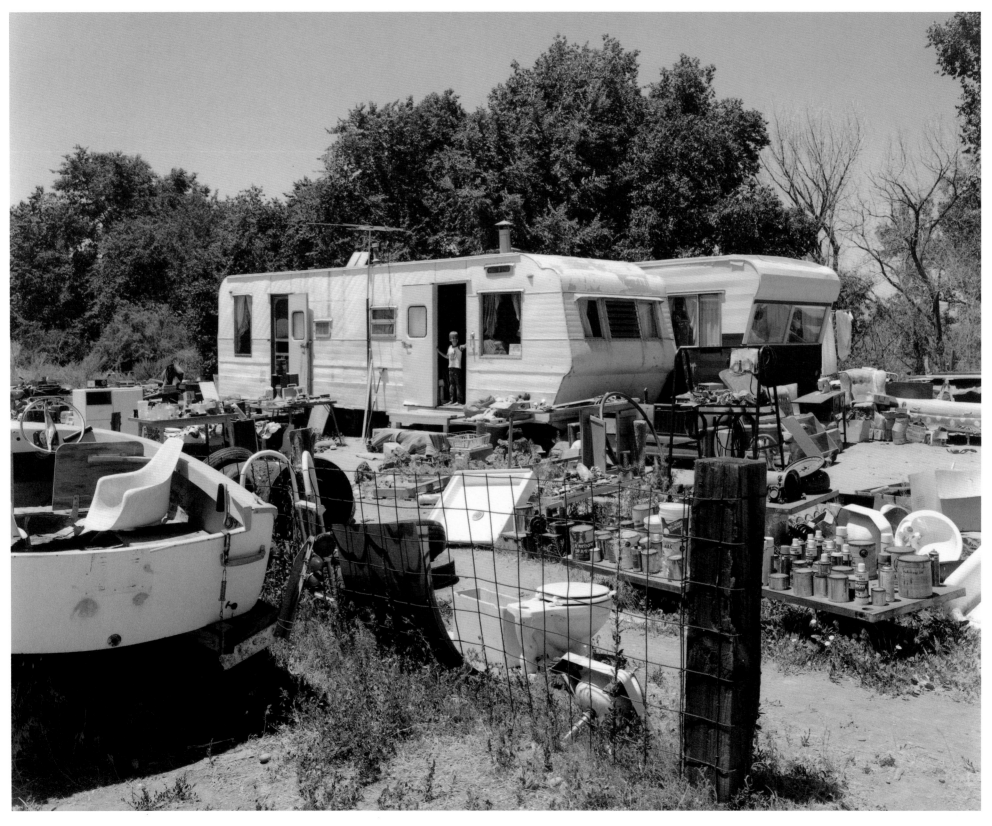

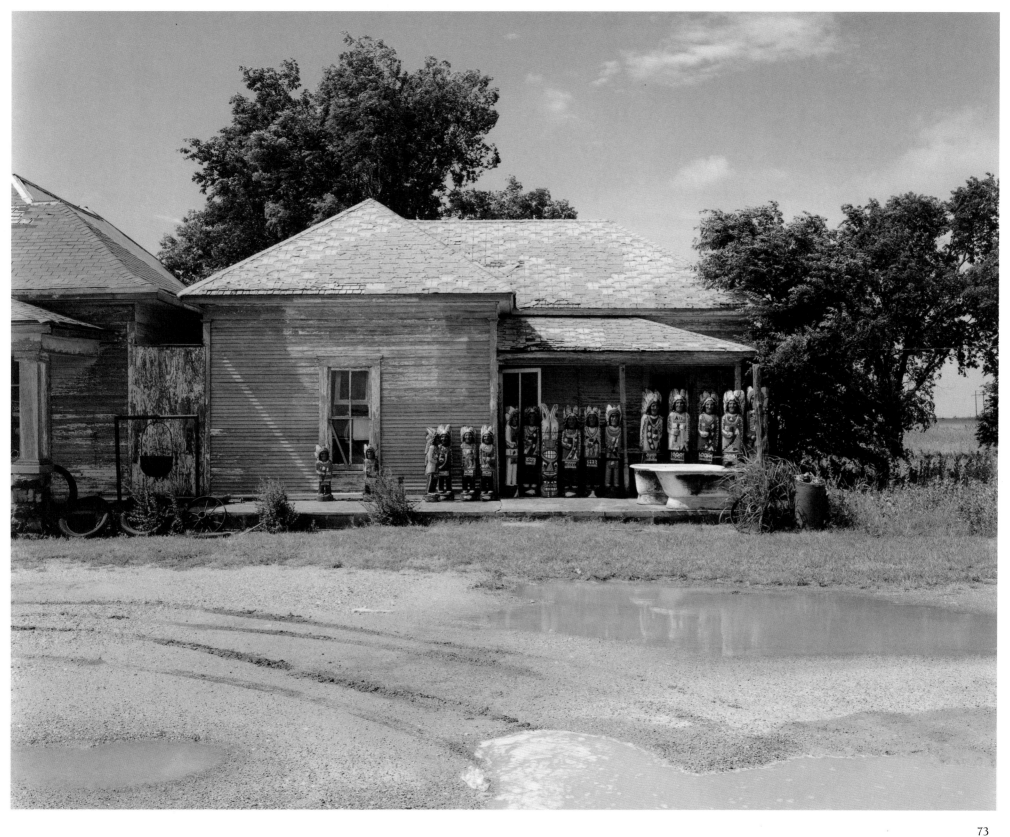

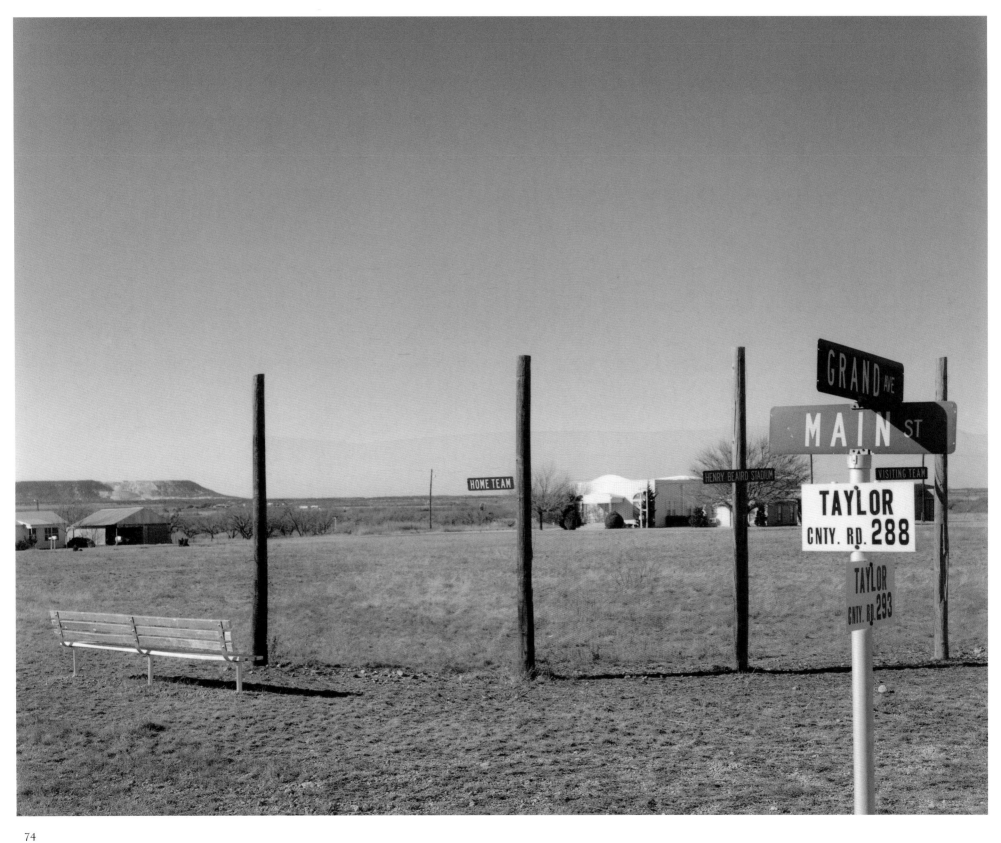

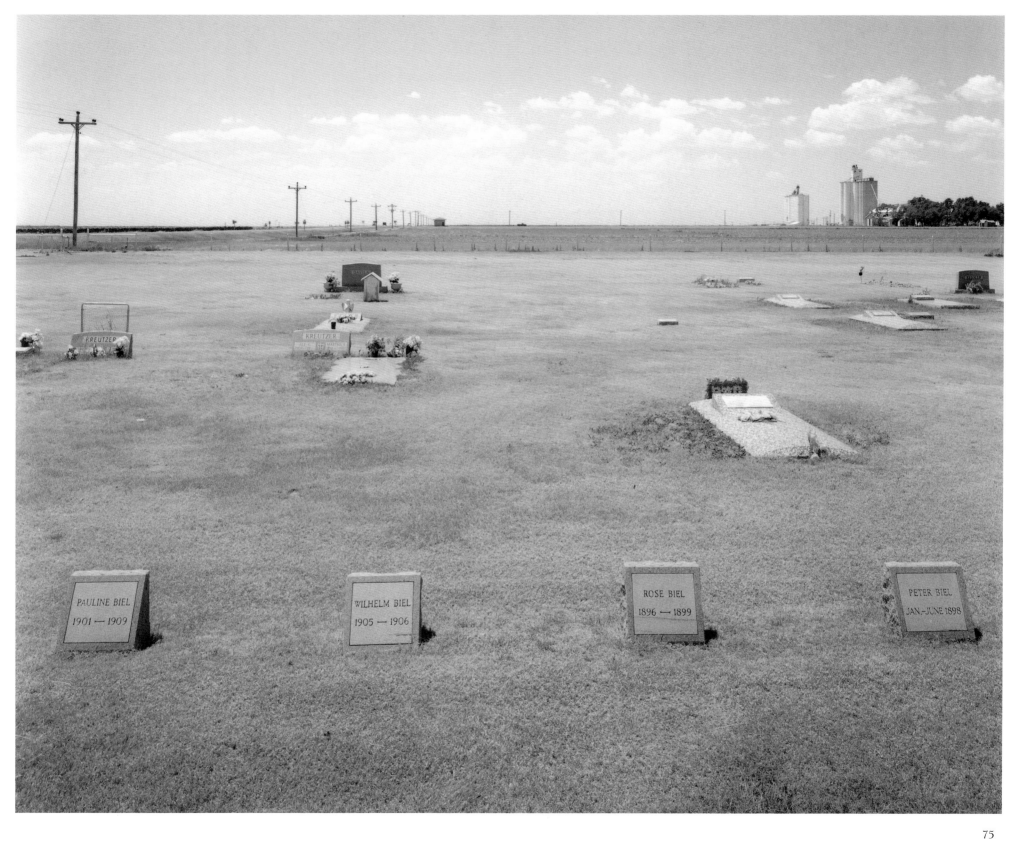

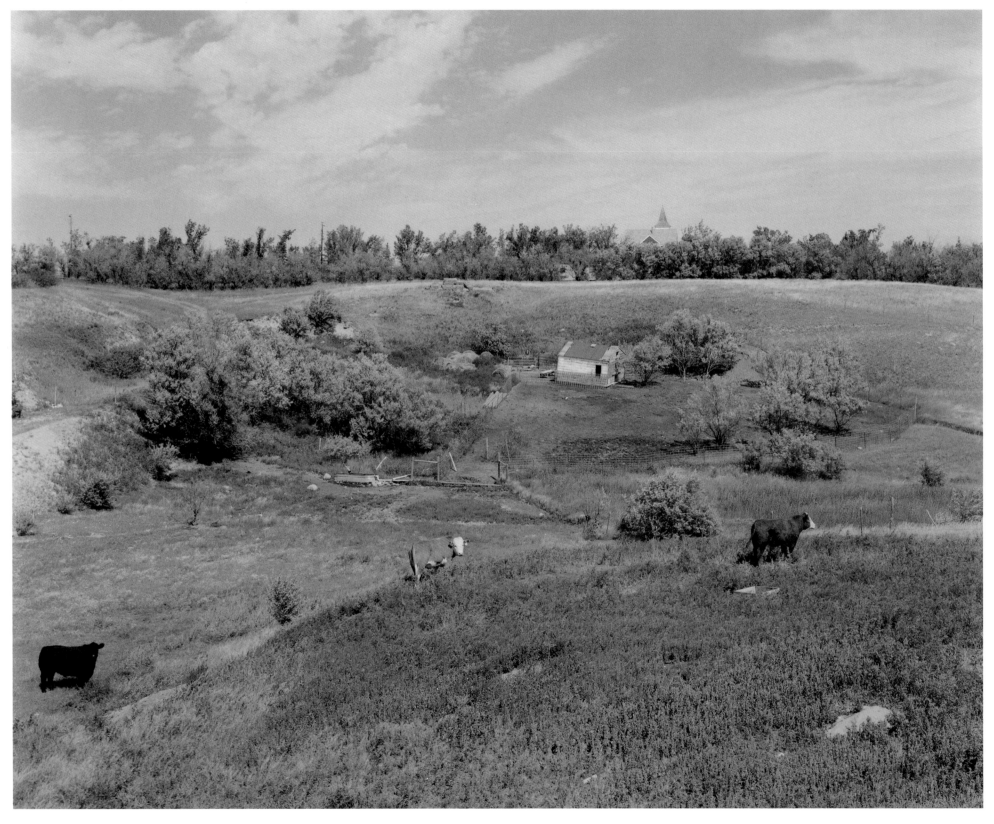

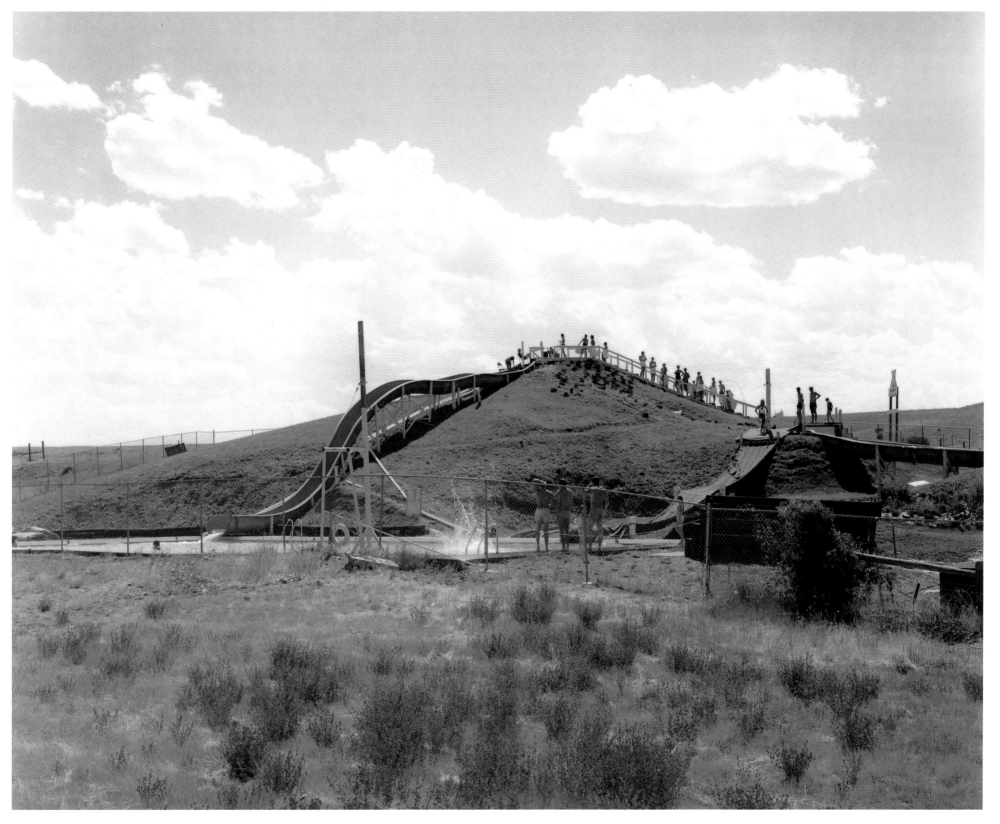

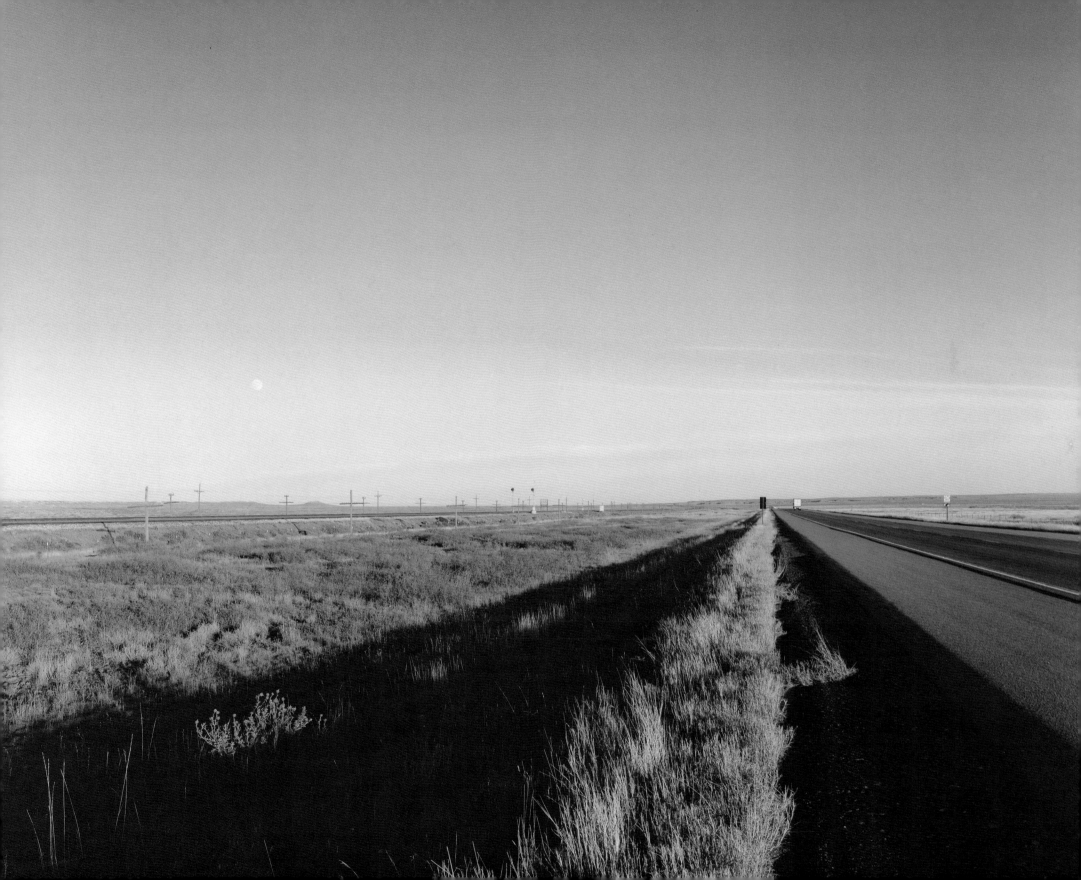

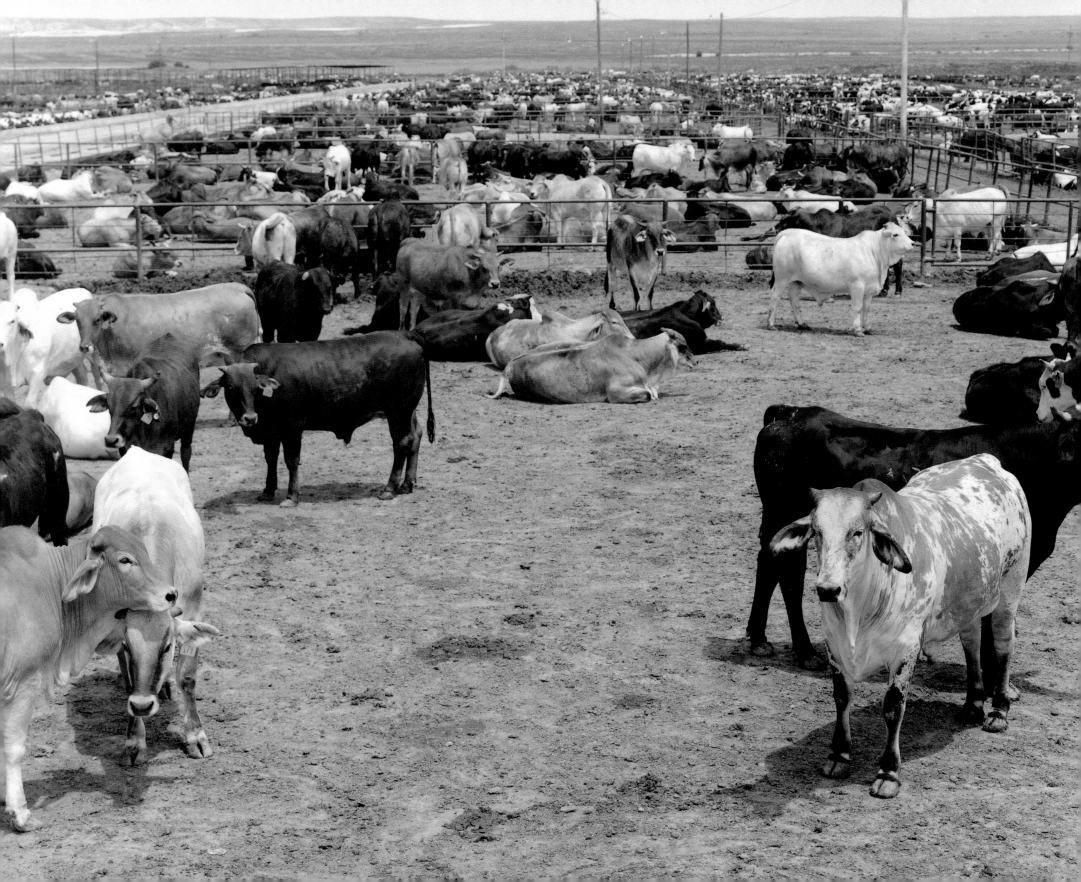

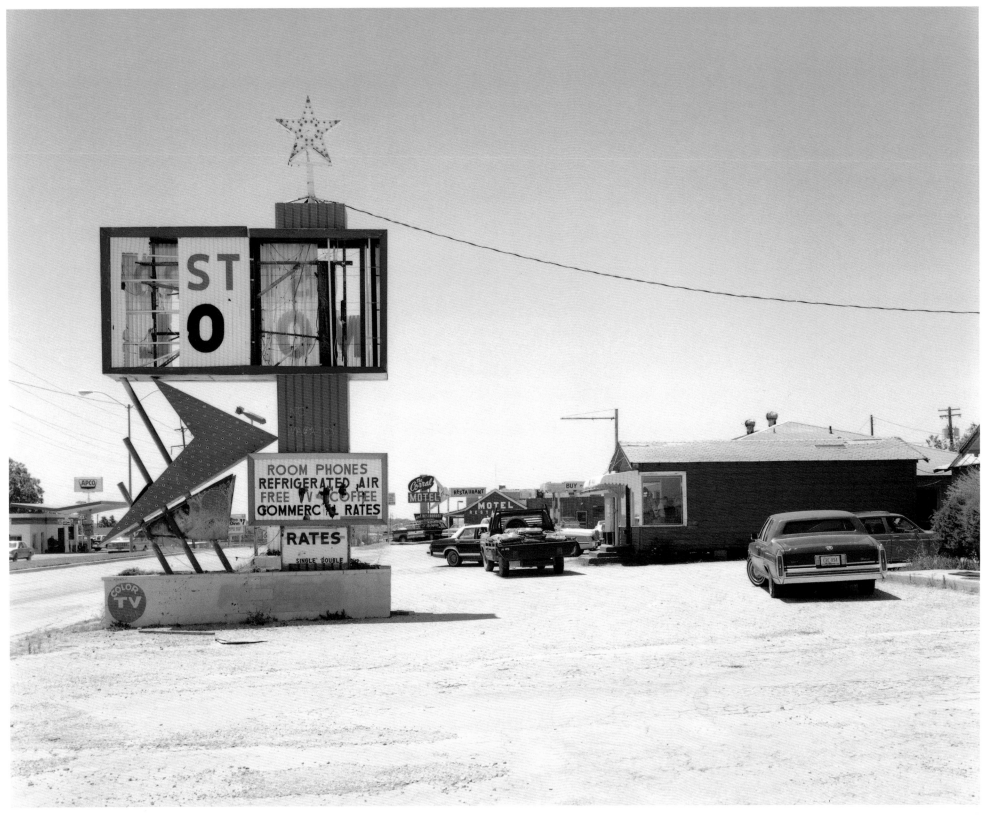

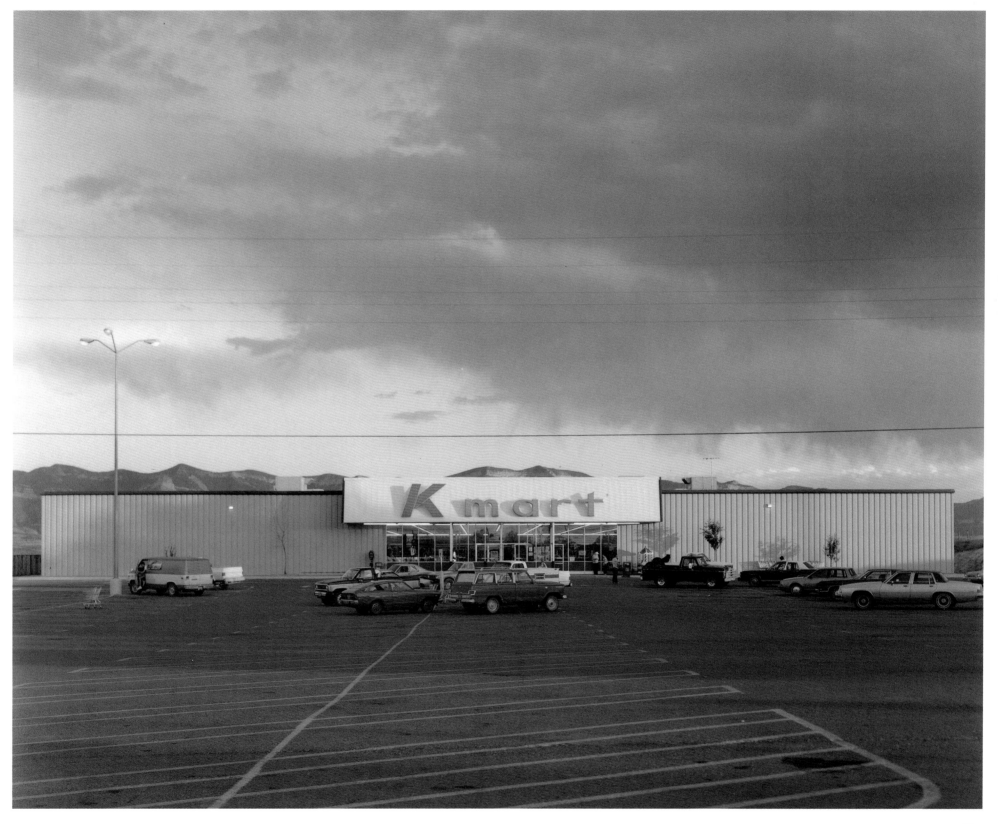

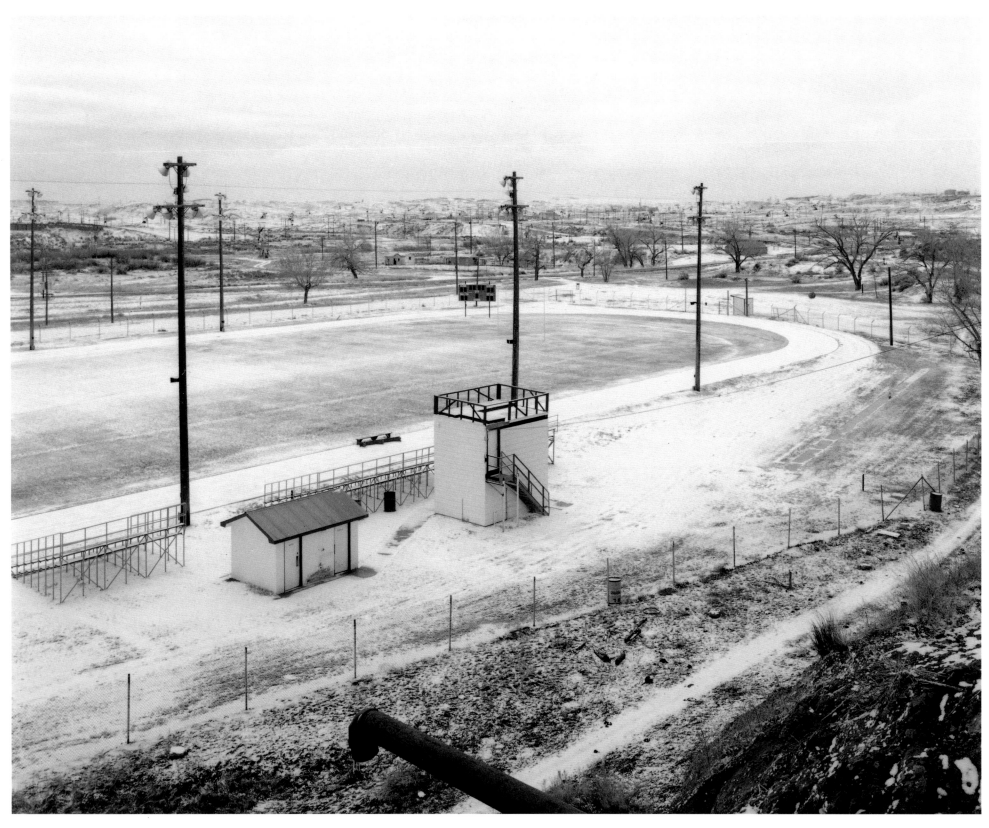

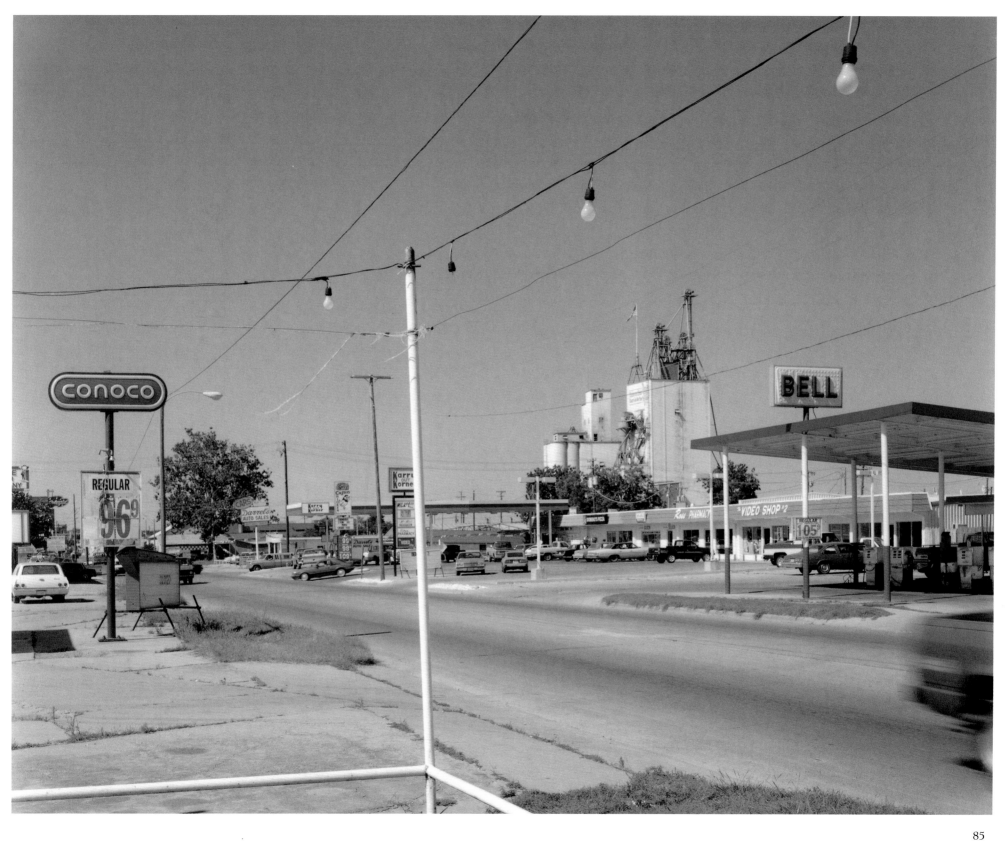

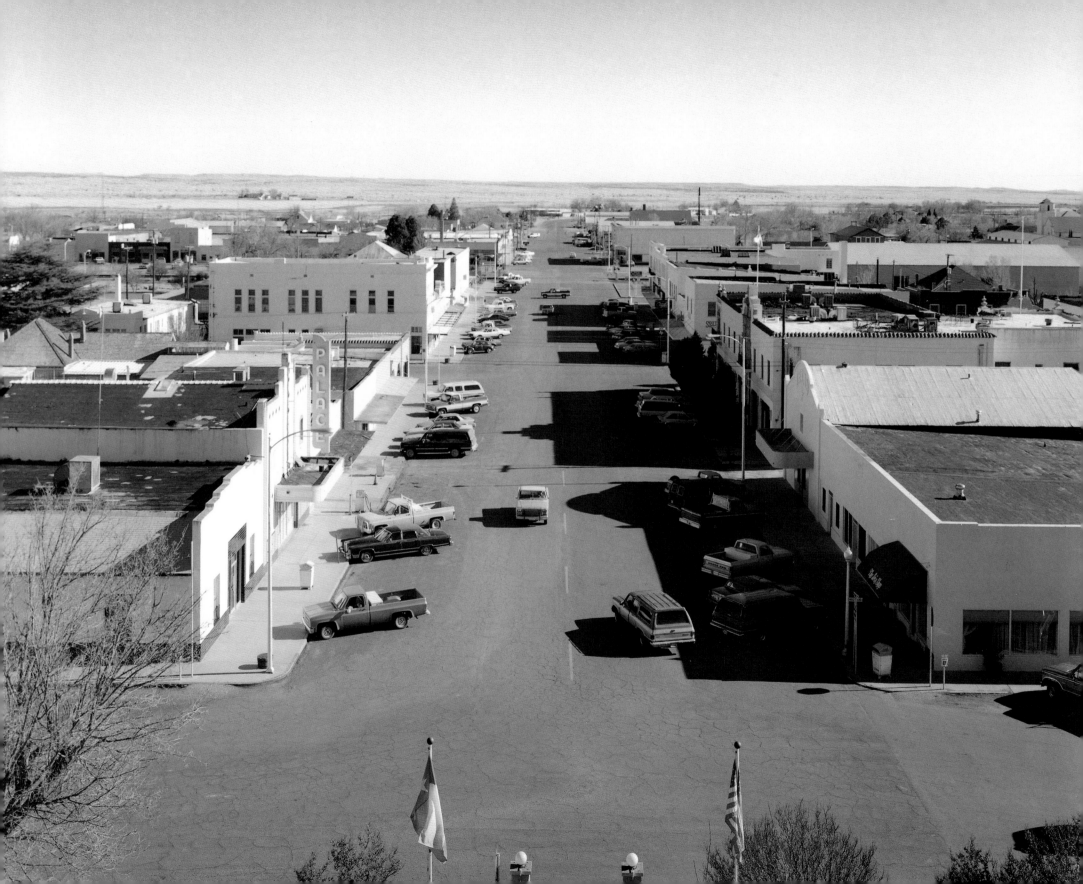

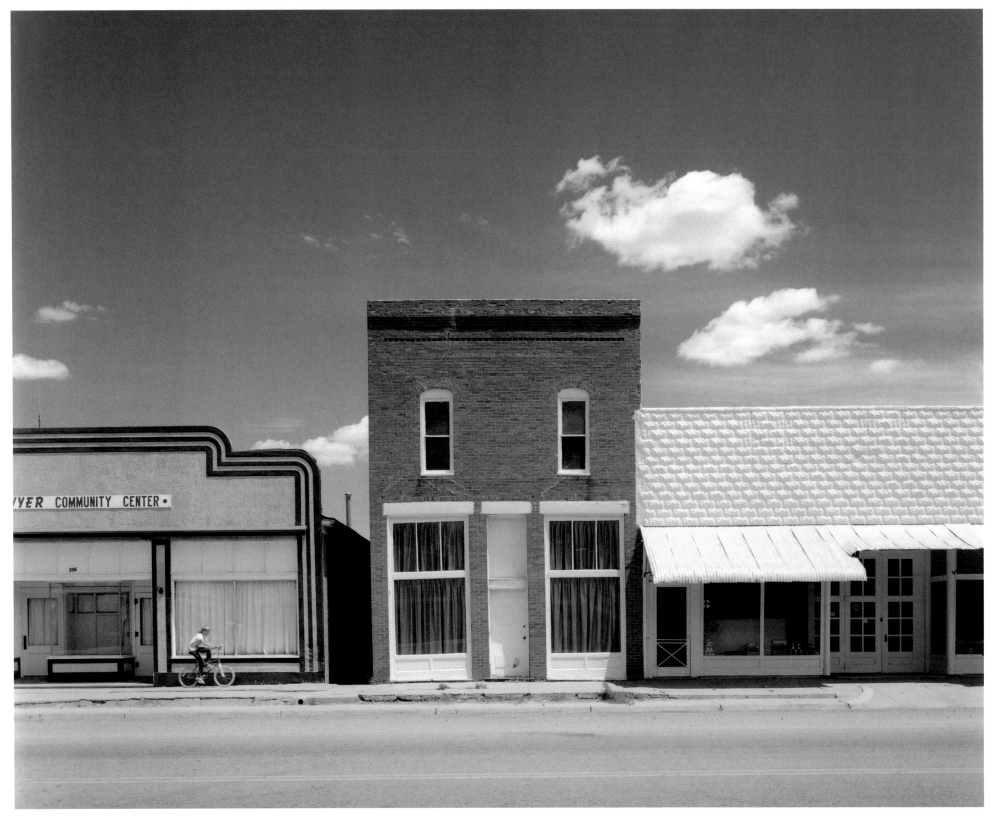

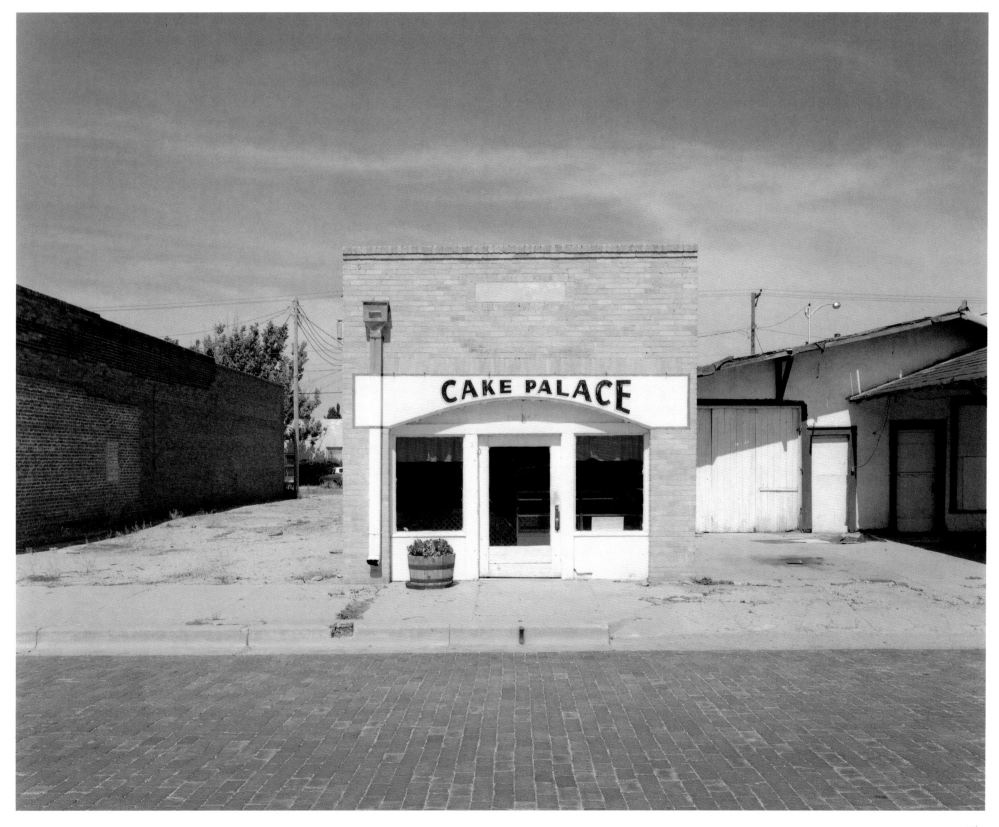

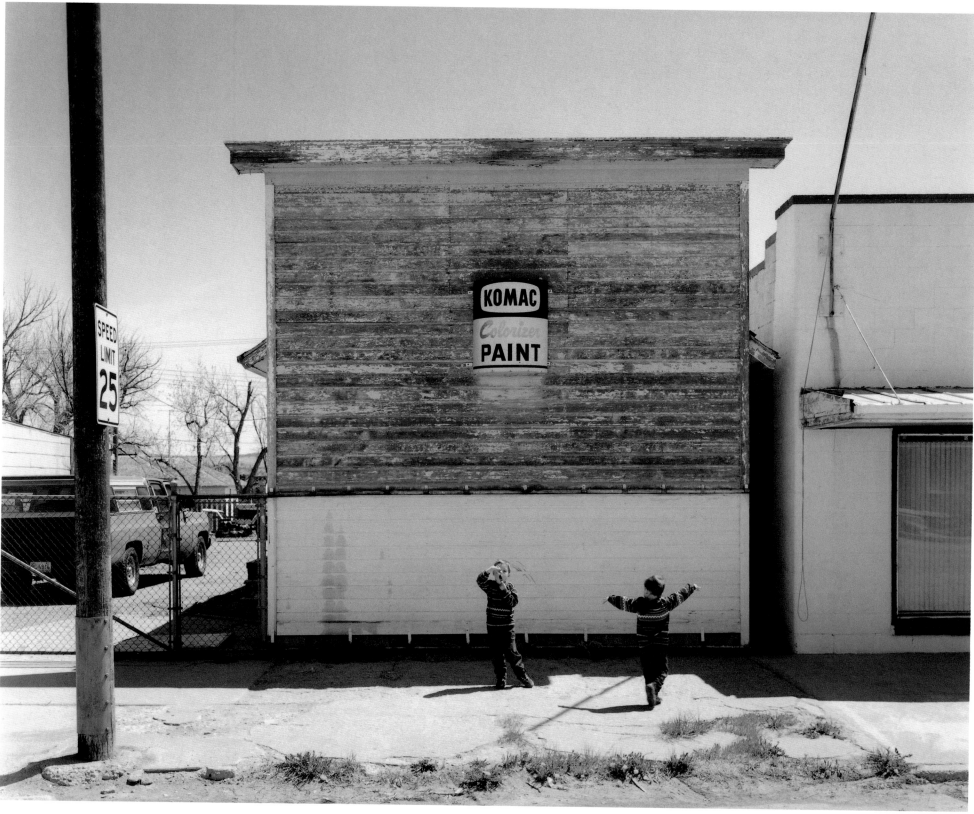

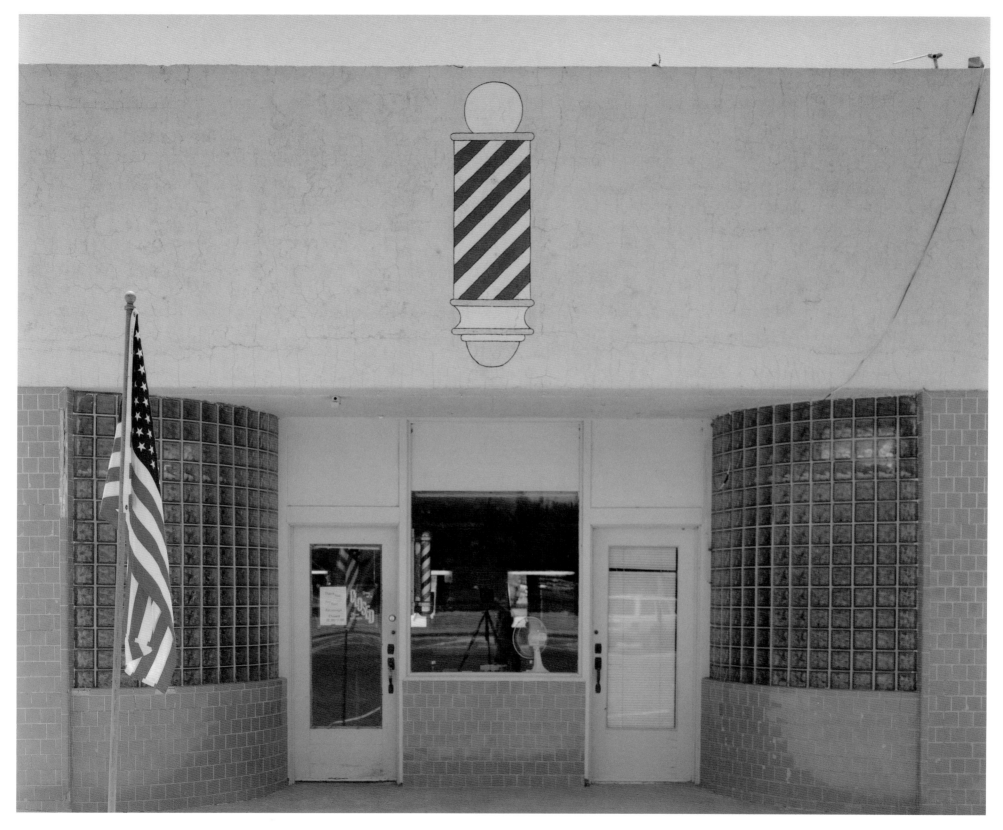

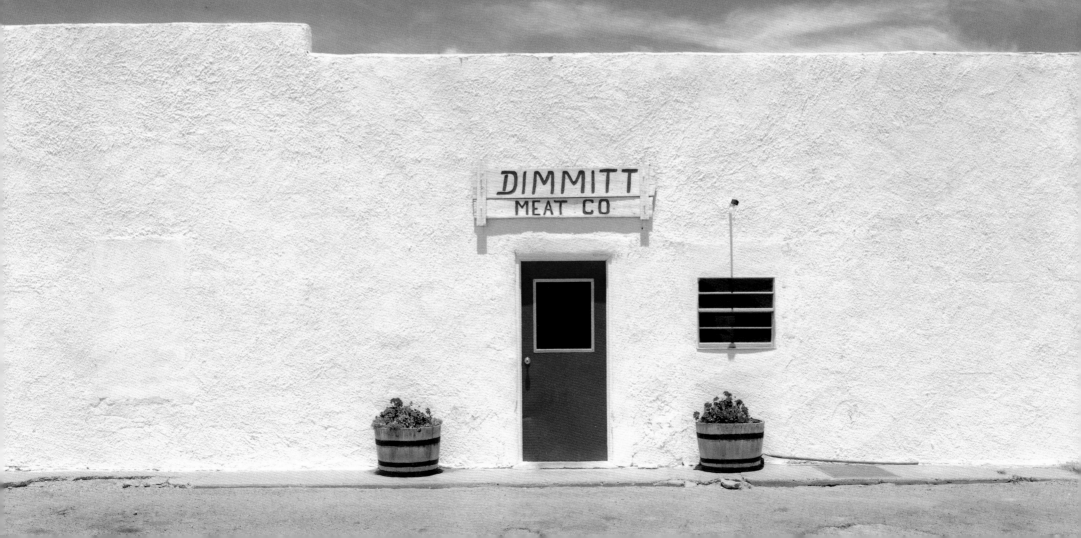

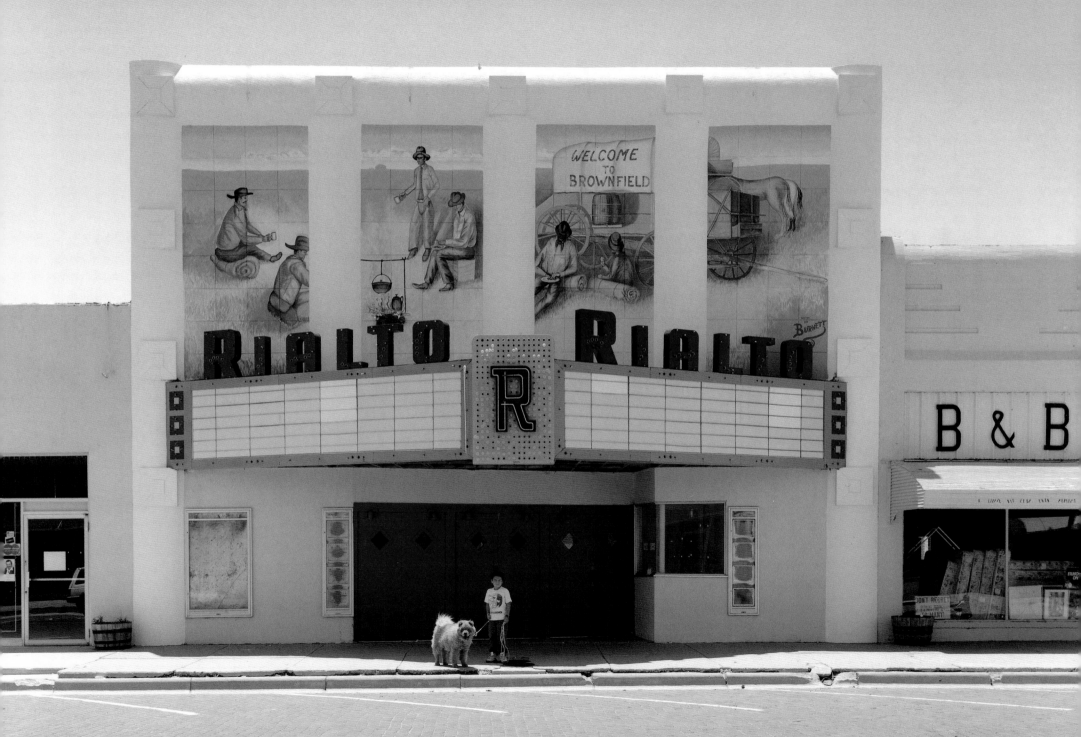

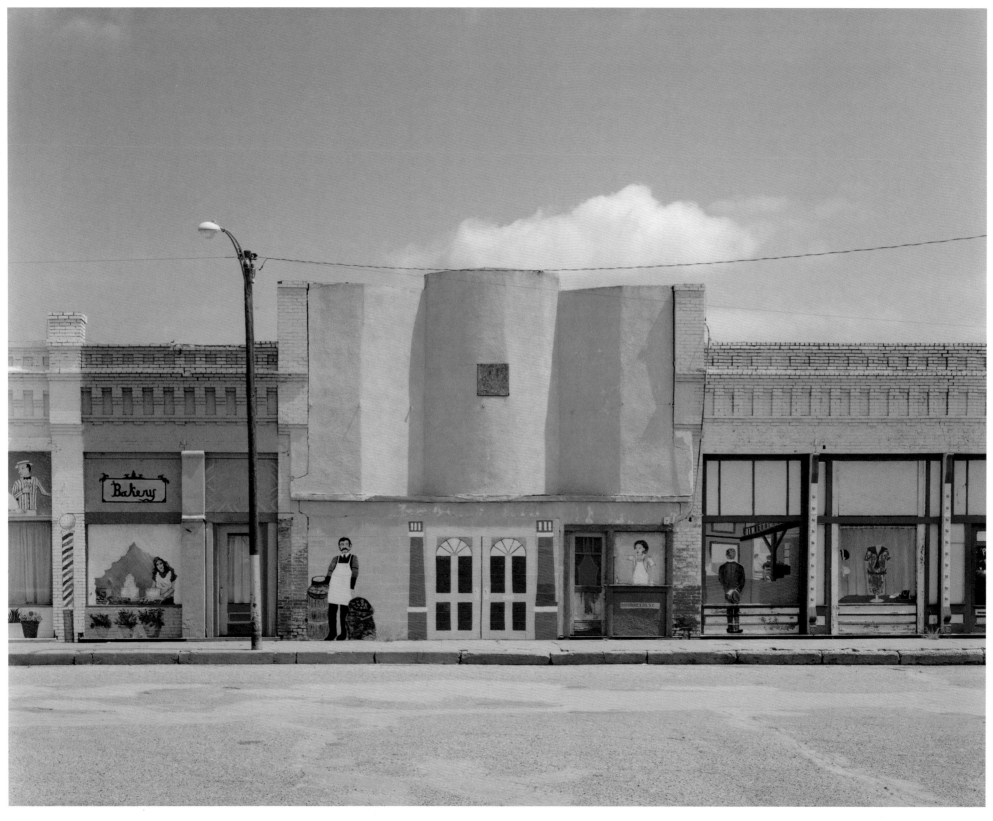

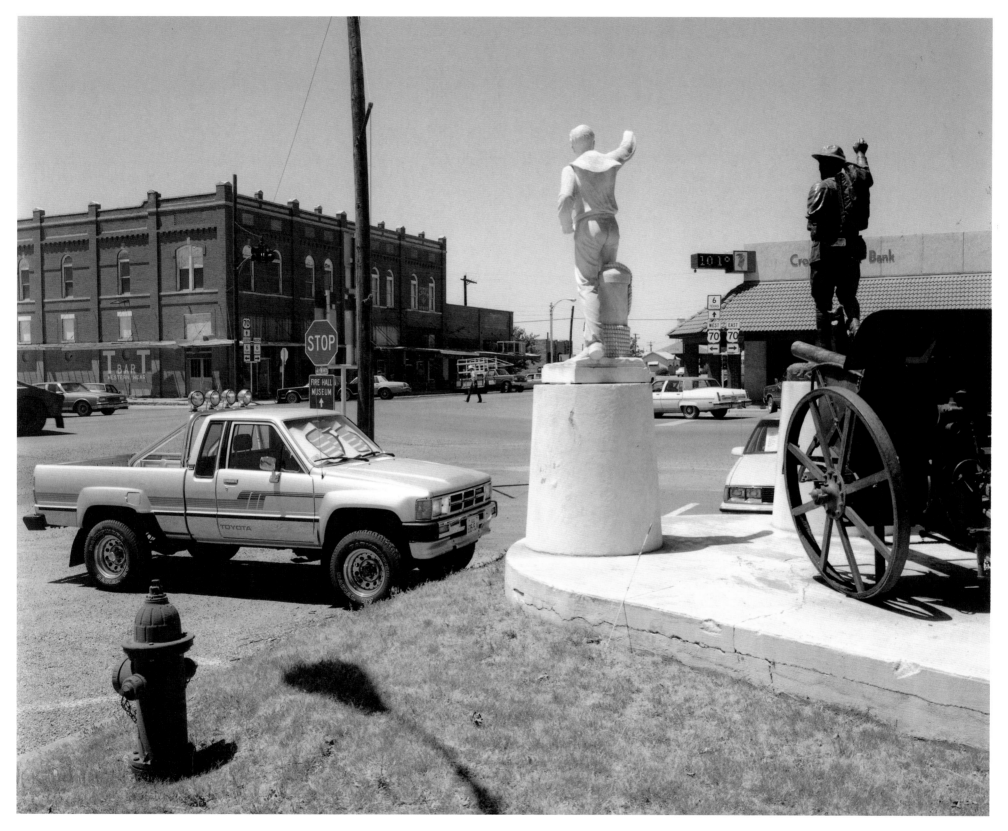

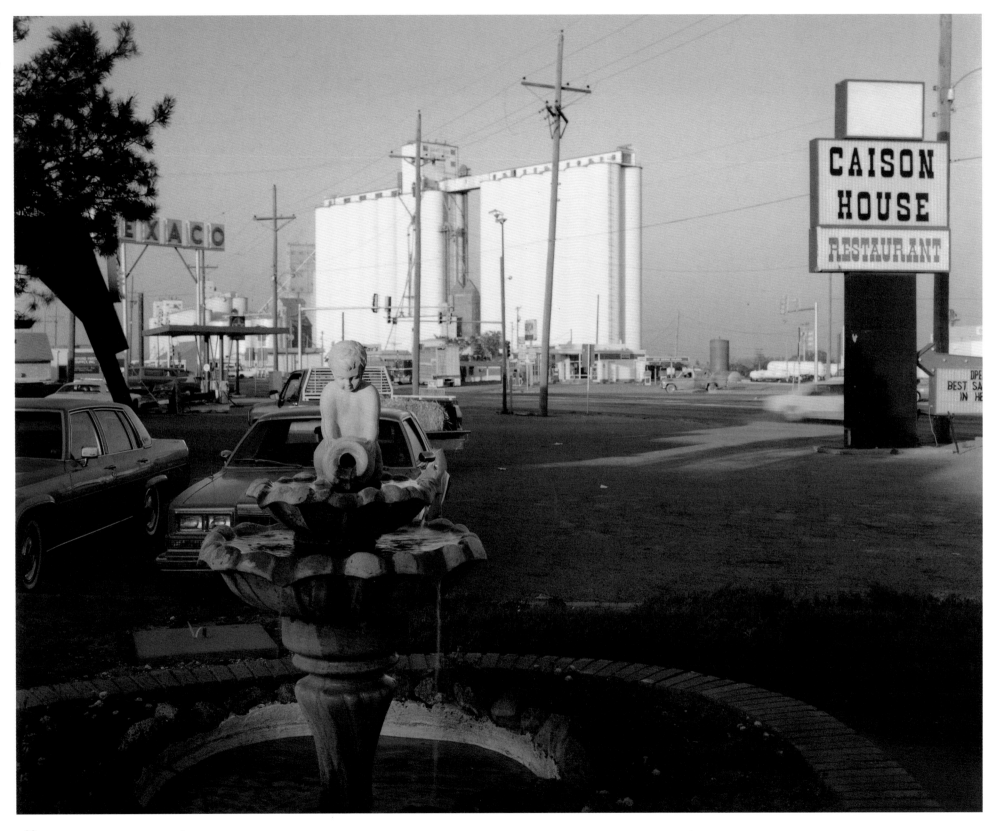

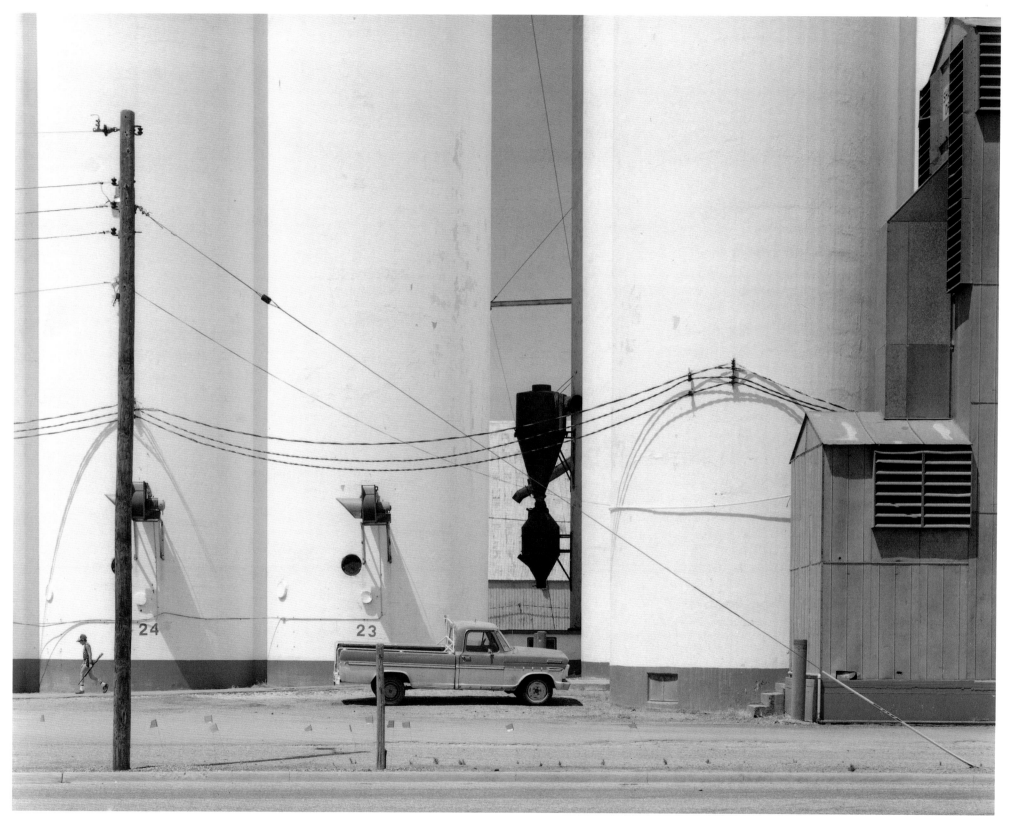

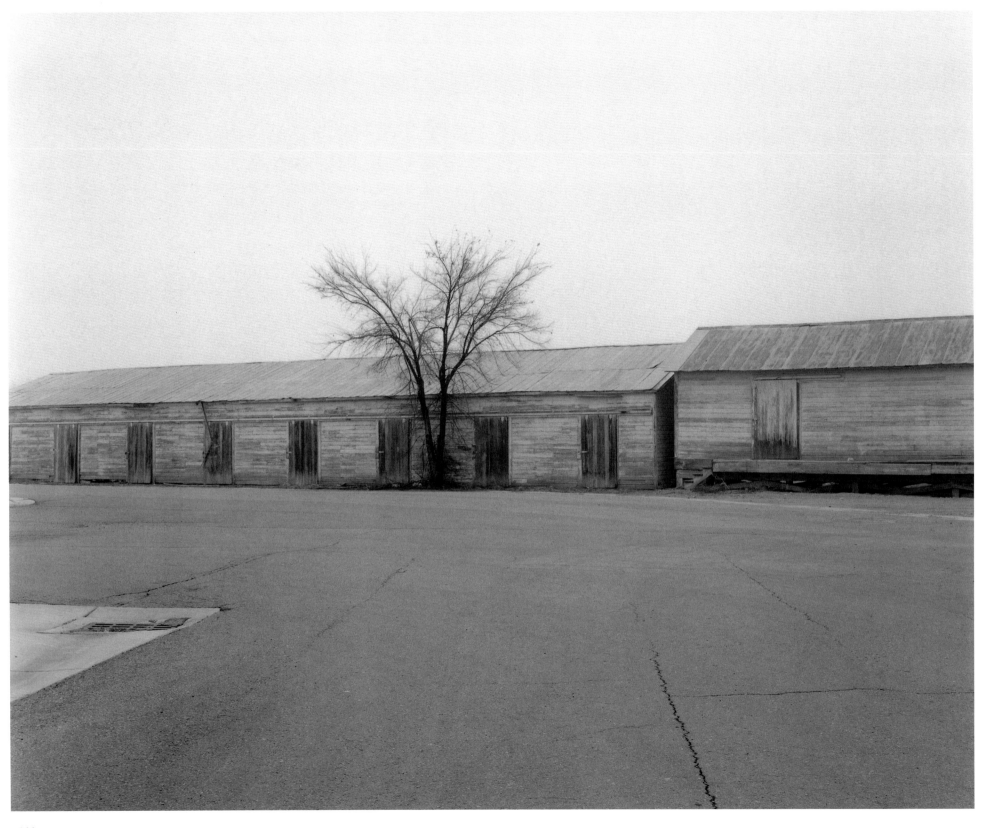

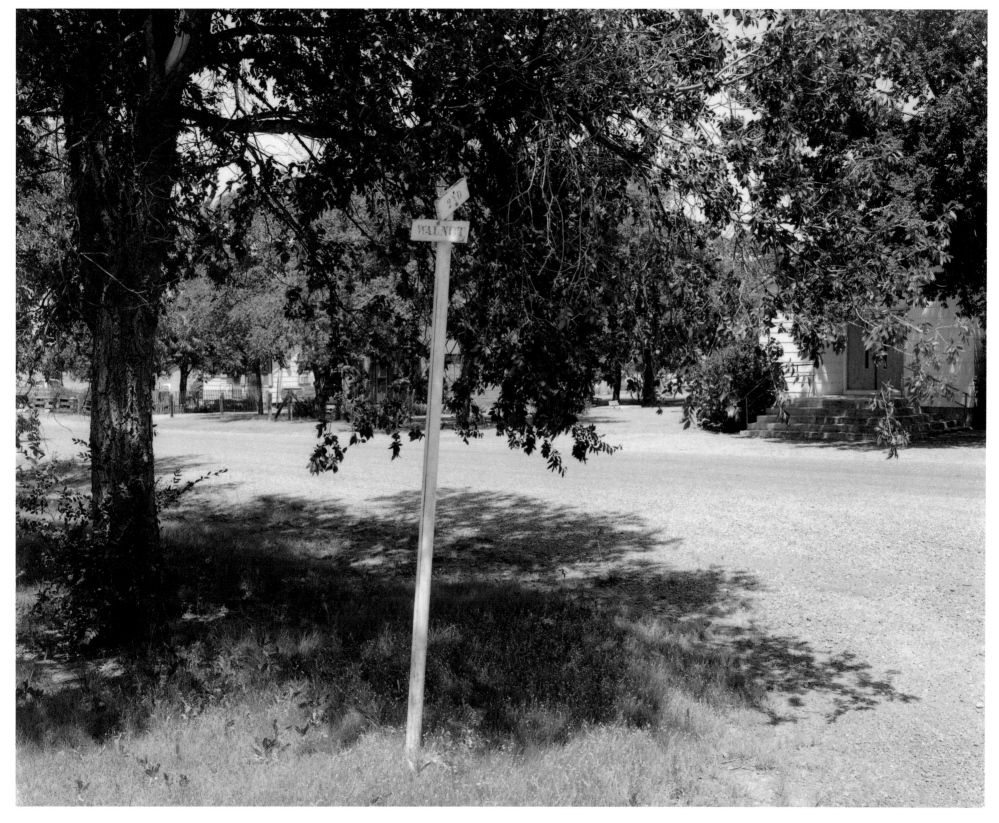

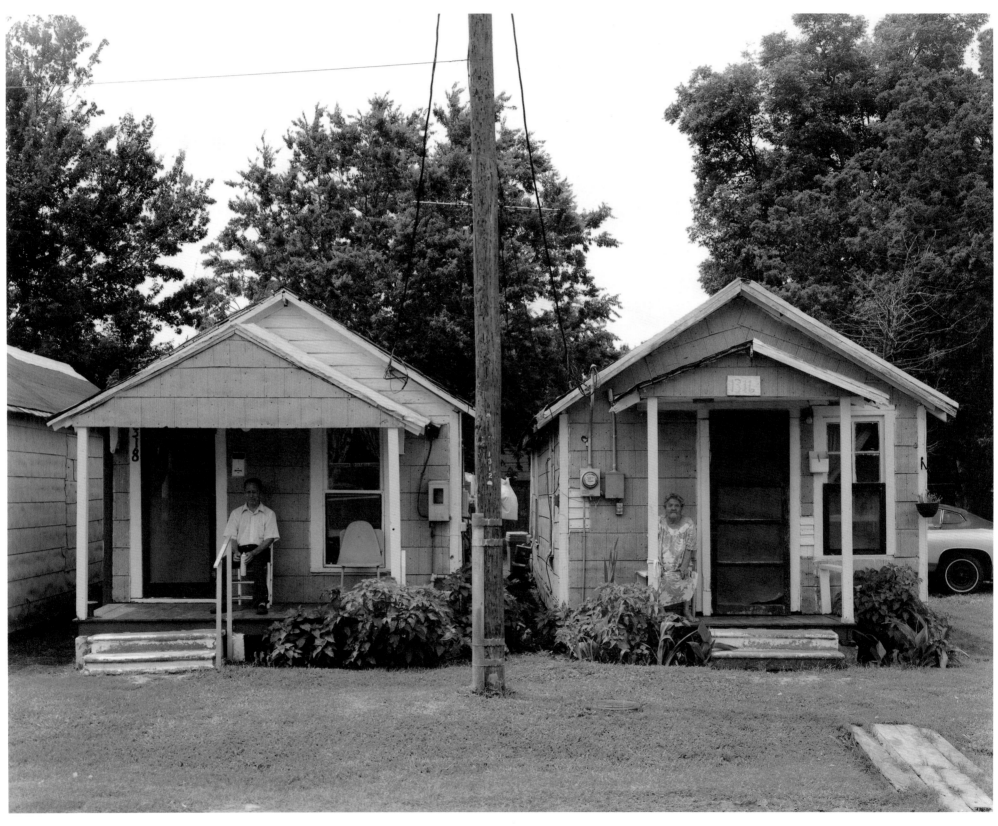

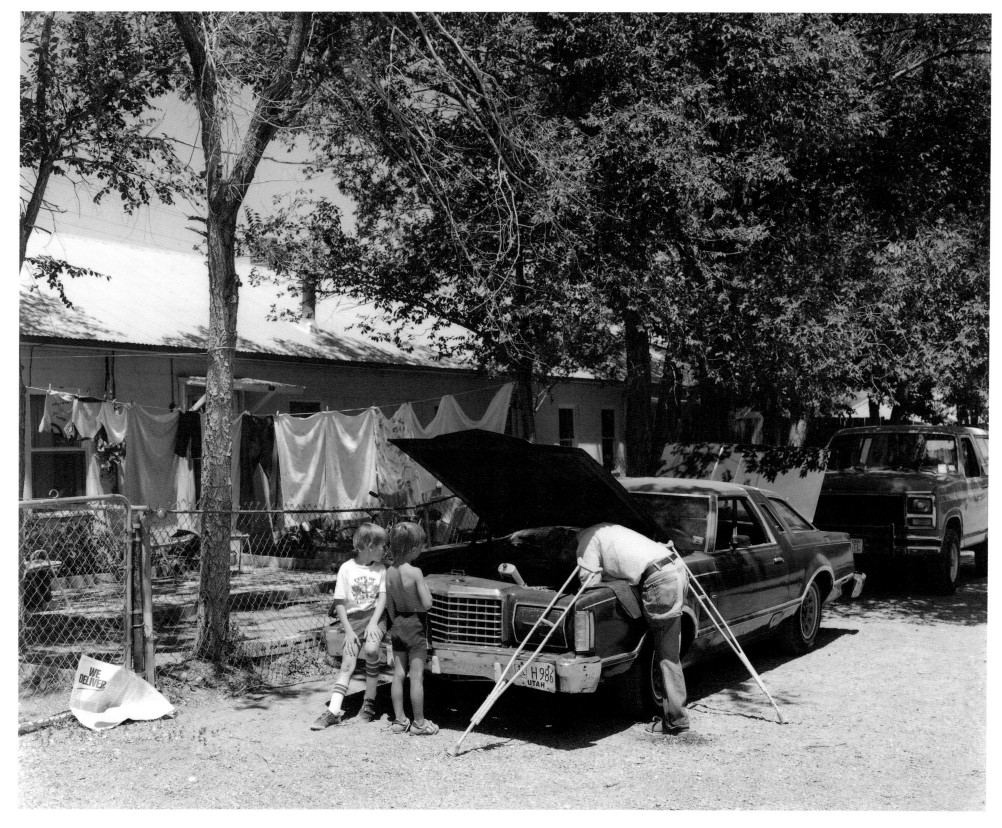

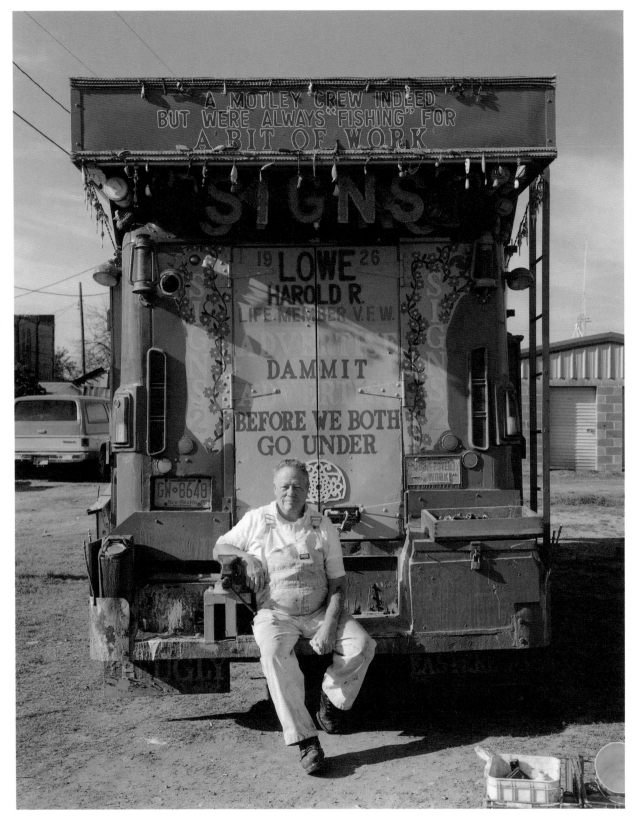

104

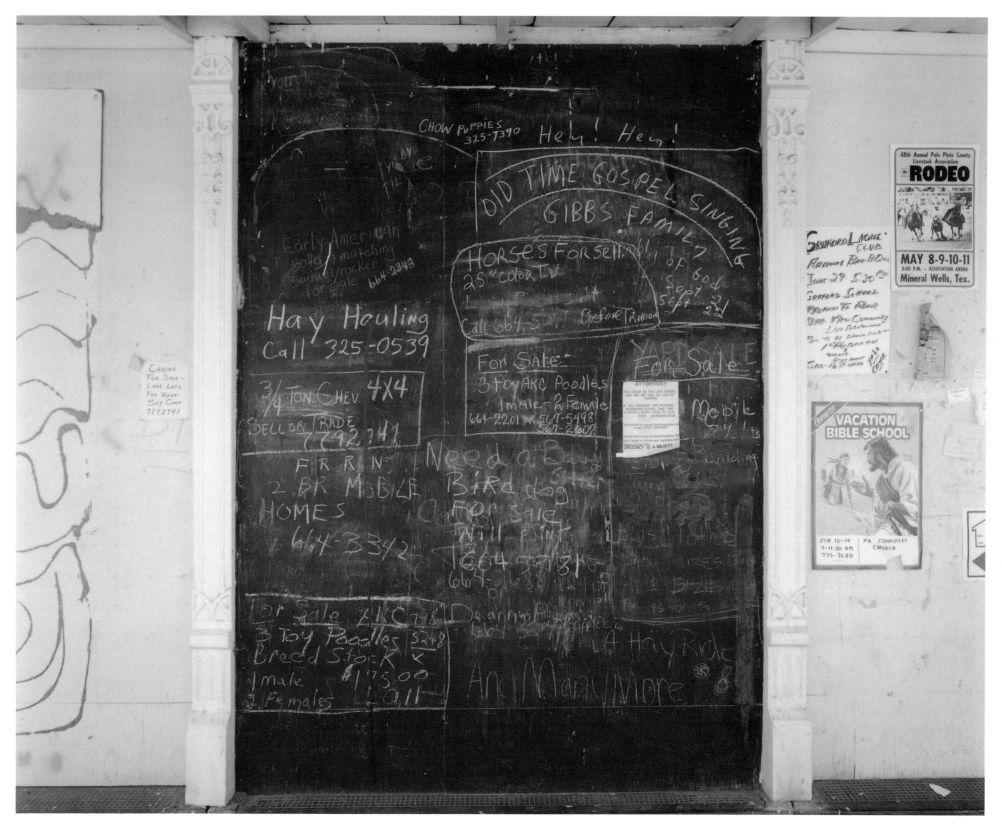

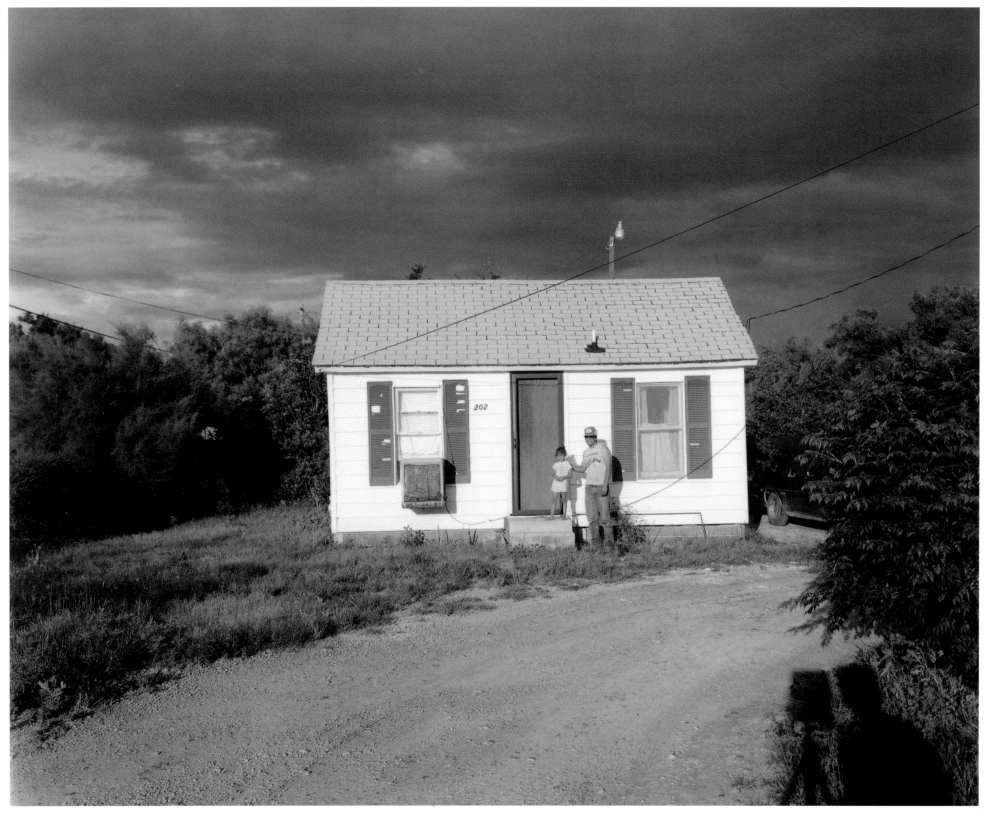

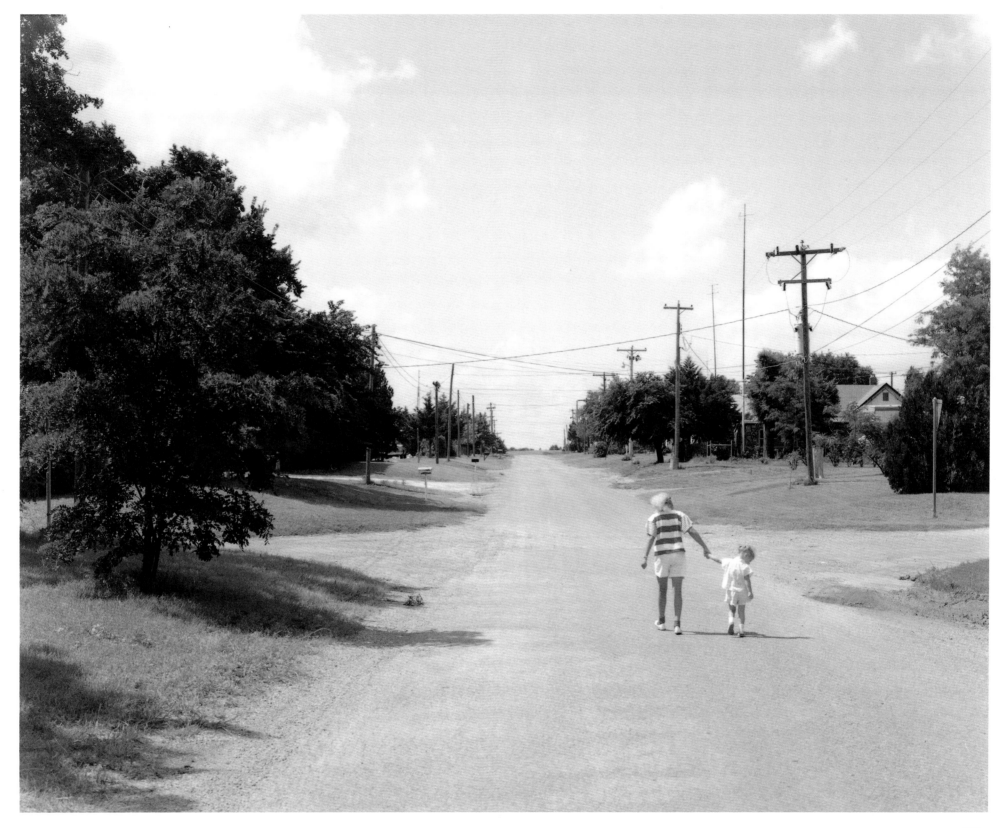

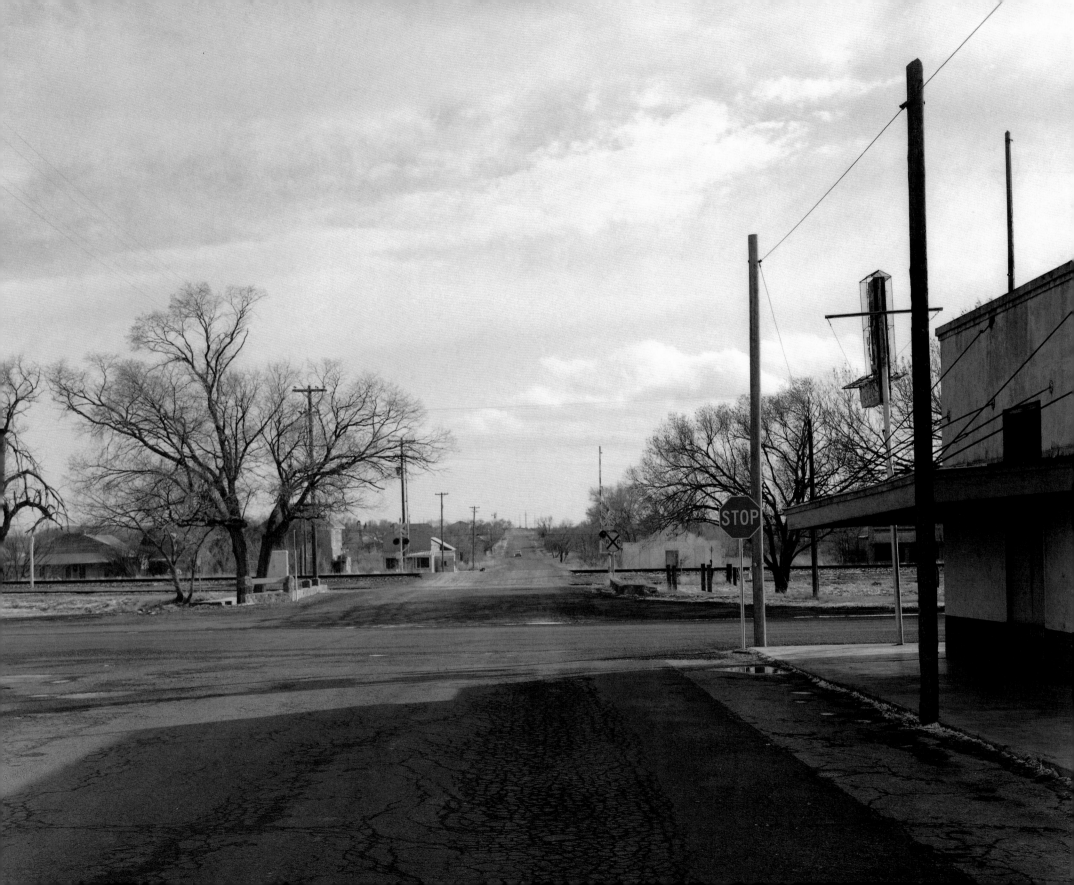

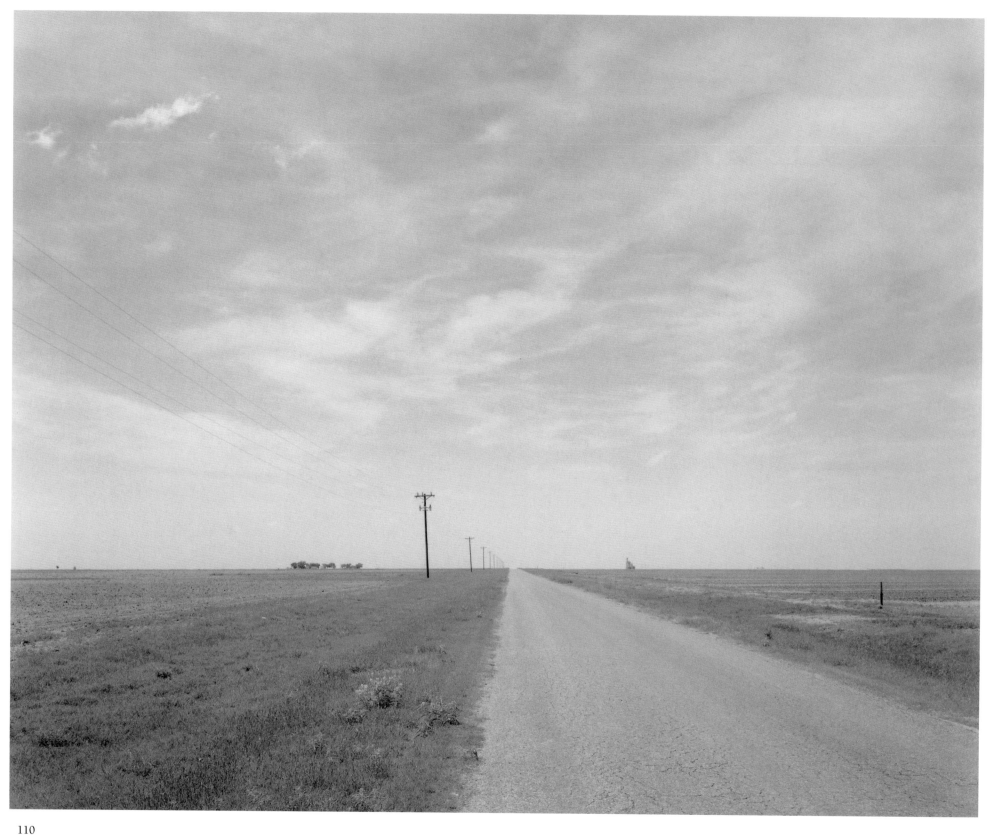

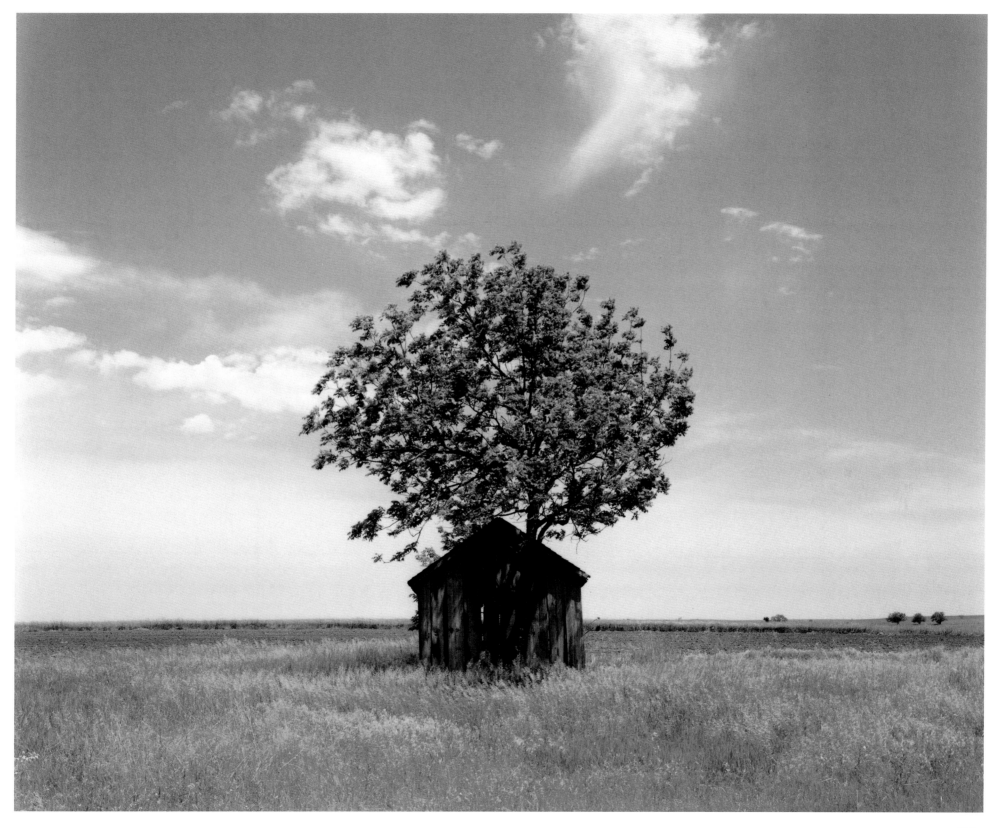

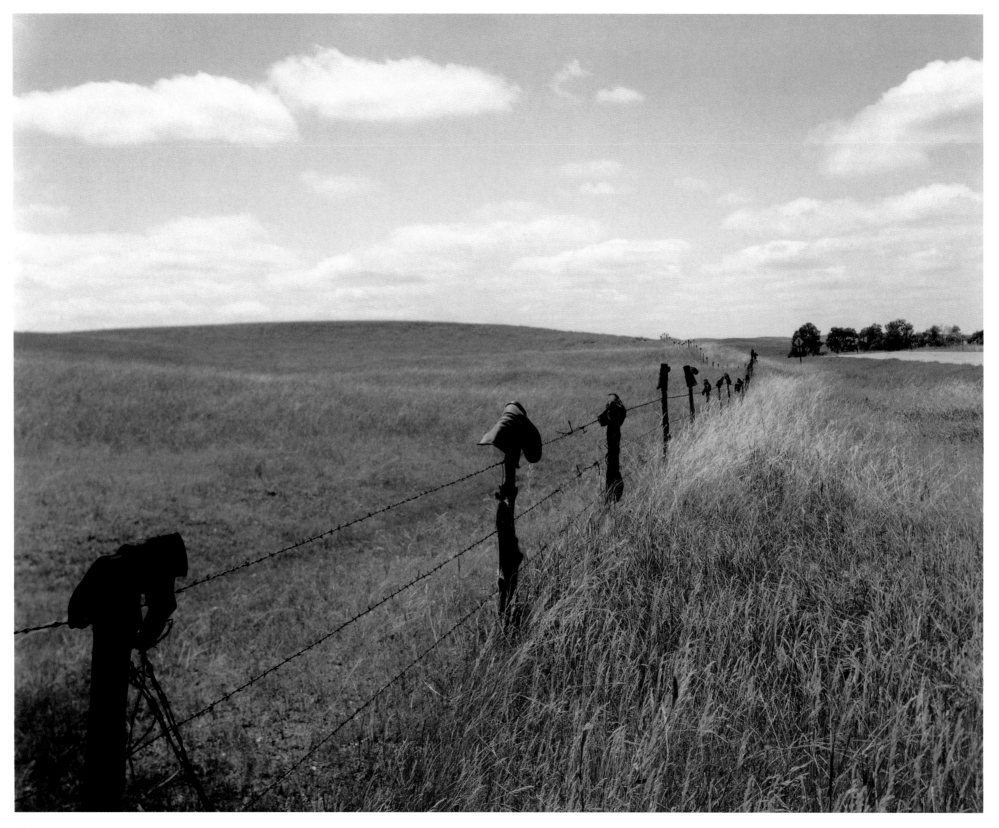

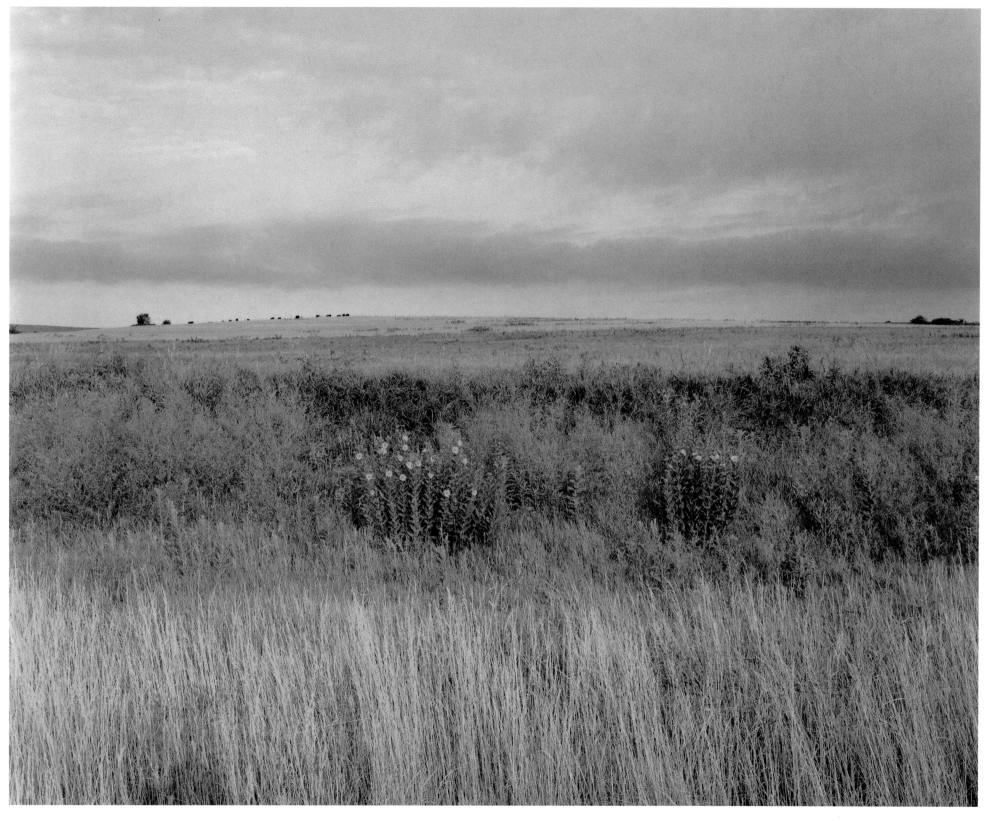

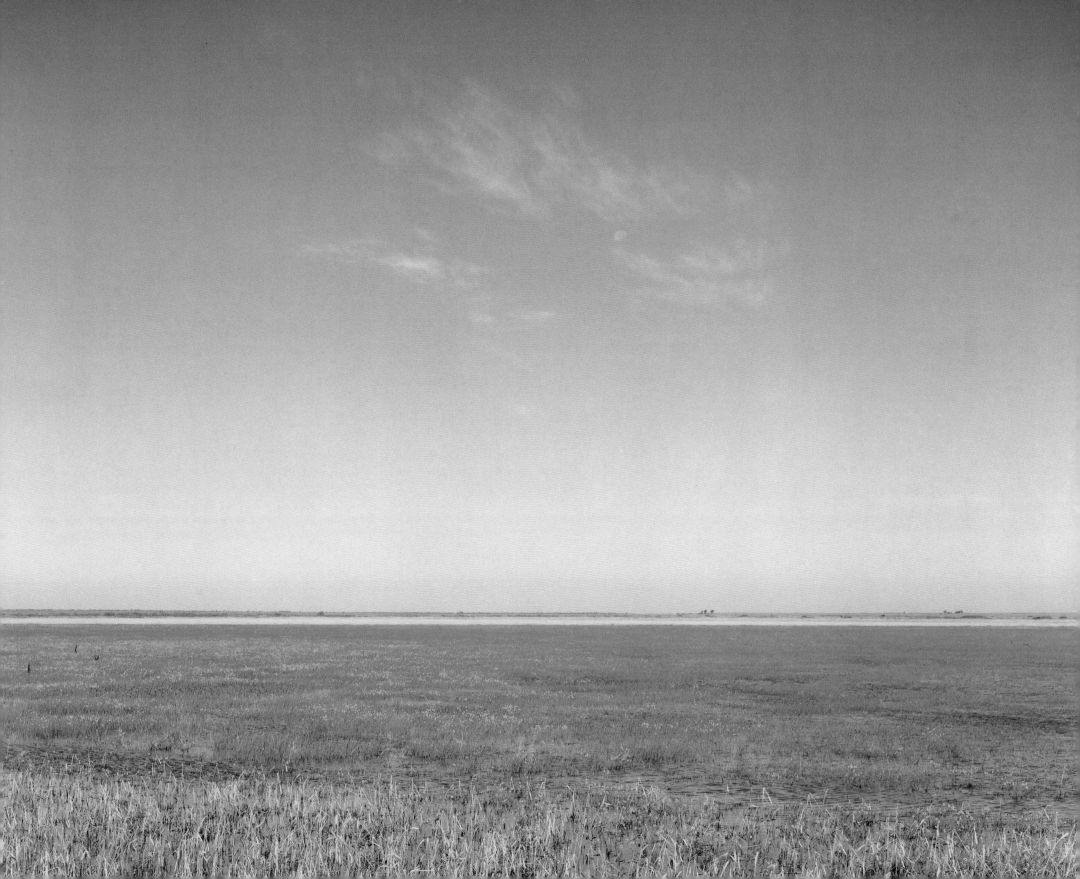

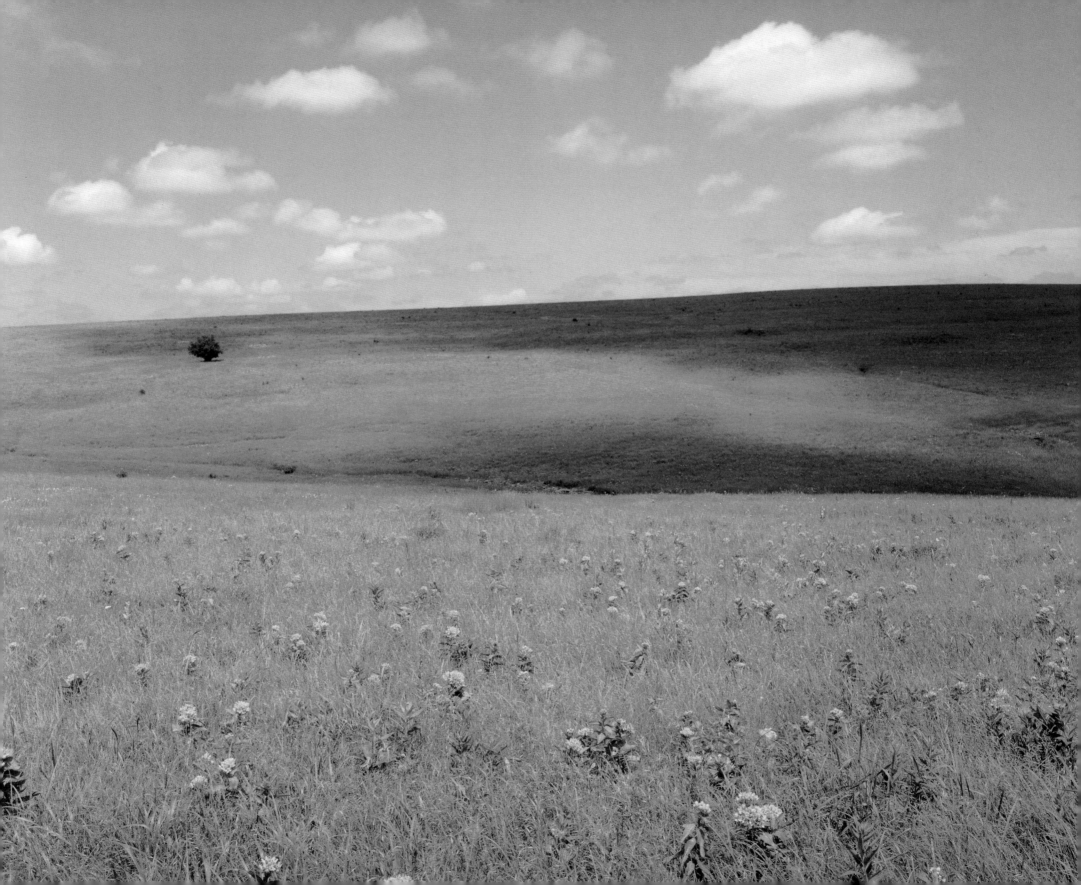

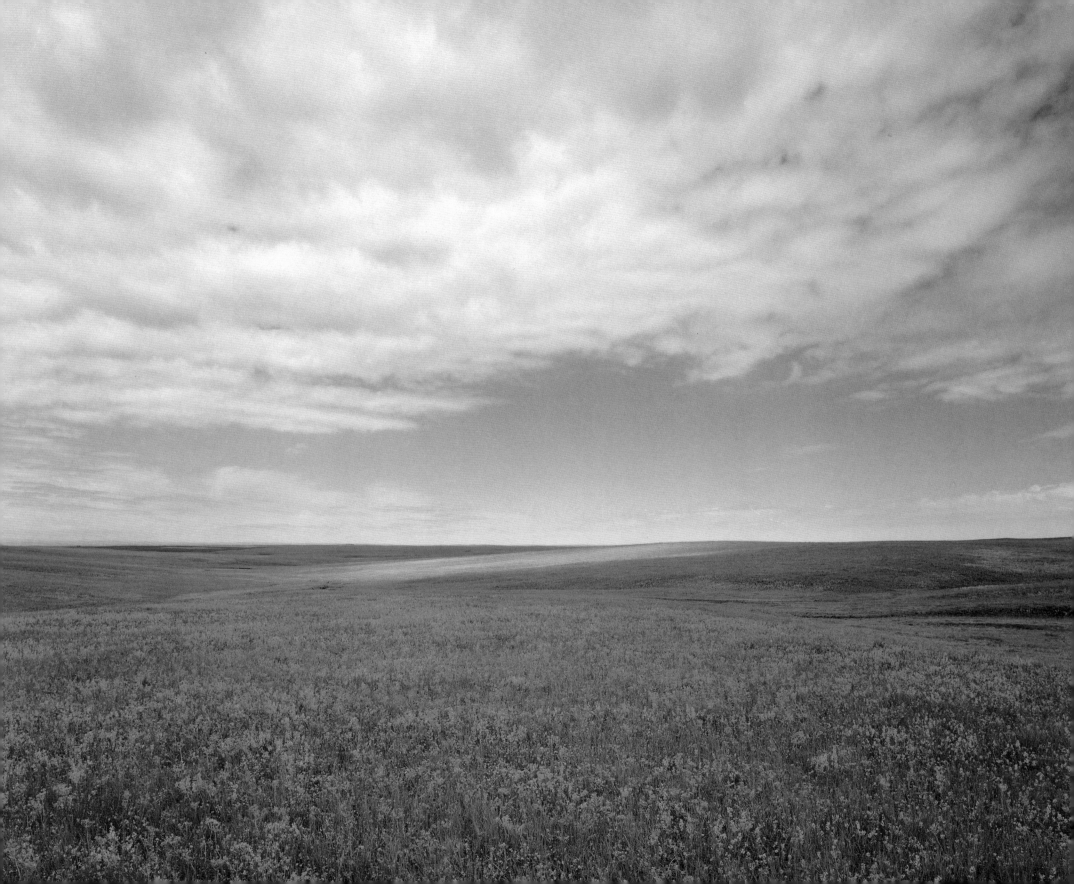

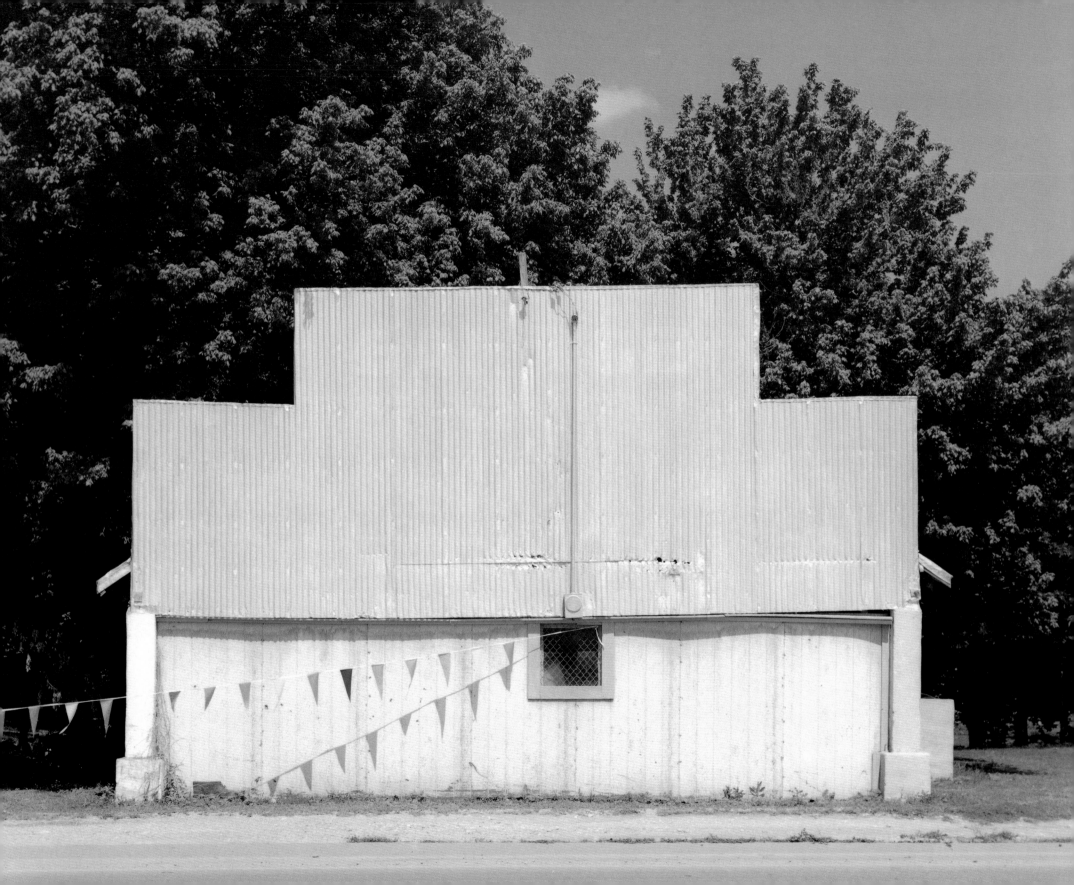

AFTERWORD BY PETER BROWN

When I was thirteen my family moved from New York to California. Every summer, we'd drive across the country again, going to and from our vacation home in Massachusetts. Well into one of the first of these trips, somewhere in western Kansas, my father pulled our big green Chevy Carryall off the interstate and headed for a small town. Victoria it might have been, or Mingo, Catharine maybe, perhaps Grainfield—anything to get off that road.

My little brother and sister were up front with my parents, and my brother Mark and I were in back, sprawled across a mattressed platform that my father had built earlier that summer. We'd spent most of the afternoon, it seemed, nudging apple cores back and forth, grinding our elbows into the remains of Triscuits, gulping down a mixture of tea and Tang that my mother had invented, and craning our necks until they hurt—hypnotized by the dipping telephone lines and the musical roar of the wind.

But we'd had enough. Looking out over those endless fields, following the zinging birds, nodding as the occasional tree blurred by, bouncing around the back as we moved on and off the still incomplete I-70, even trying to read the old Burma Shave ads on the smaller roads (always missing a crucial line) seemed stupefying work. We felt flattened by the heat, by the monotony of the landscape, and by everything else on that wide black road beneath the blank, blue sky.

My father worked his way off the ramp, through a grid of wheat fields, and onto a shaded Main Street. He parked outside a small, white-framed grocery store, and with the engine clicking in the heat, wiped the sweat from his glasses and told us to hop on out. We plopped down into the dust, pushed through a screen door, and with sudden recognition, headed for the Coke cooler.

As we fished around for bottles of pop (soothing our hands in that cold water and flicking it into each other's faces as we looked for Birch Beer or at least a Fanta Orange), a crew-cut kid of about ten appeared at the door with his little sister, both of them barefoot and framed in the afternoon light. The boy wore blue jeans and a white T-shirt and held a small cardboard box. His sister, who was shuffling quietly from foot to foot with her head tilted to the side, carried an empty milk bottle. She was wearing a simple dress and she was humming.

The boy was quiet, cool, and tan, utterly at ease, and oblivious to us in a natural way. Immediately, I pulled myself up into my age and tried to ignore him—but I couldn't. The little girl finished her dance, and the two of them entered the store almost noiselessly, floating on light it seemed. They nodded their heads and smiled at the store clerk in greeting, and the boy said that his mother had sent him out for eggs but that she hadn't been able to find her basket at home, so would the woman fill up this box instead?

The woman behind the counter, smiled, nodded, called him by name, took the box, asked him how his mother was doing—if she were any better—and handed him back a wire basket, the likes of which I had never seen. Then, reaching into a straw-lined wicker container, she carefully plucked up one beautiful brown egg after another, and almost tenderly placed each in the basket's mesh.

When she was done, the girl, who was maybe four, rolled her milk bottle onto the counter with a grin. The woman filled it from a stone pitcher from another cooler, capped the bottle, and gave it back to her. The children thanked her, talked about a catfish that they had caught that afternoon, and promised they'd return the basket the next day. They pushed through the screen door into the late afternoon light, padded through the dust, out under those cottonwoods, and walked down the street talking quietly, hand in hand.

In a way, my work on this book began at that nostalgic moment—as an envious tourist peering into a world he knew nothing about. Here was something as quietly beautiful as anything I had seen in my life, and to me, an easterner still, utterly exotic: an America that I had been taught to believe was ubiquitous, and yet an America that I had seldom witnessed. That small town in western Kansas seemed utterly foreign to me.

My family's cross-country trips continued. Each summer we would take a different route, but twice each summer we would cross the Plains. There's no avoiding them, and they drew me in. Initially, it was an appetite for scenes like the one just described, but soon the space, the color, and the light made their impressions as well.

On the road, my parents would wake us up each morning at five and we'd drive a hundred miles or so before breakfast. As we snoozed in the back, dawn would break, color would spread across the horizon, my mother would pop open a red-and-silver thermos, and the aroma of coffee would fill the car, as the car filled with light.

We picnicked at rivers and on open land, and at night we would often camp and I would fish. And through it all, my imagination would take me back in time to the settling of the West.

In my later teens, friends and I began to hitchhike across country, and after we had cars, we began to drive. Through college and eventually graduate school (where I took photography seriously) most years included a trip through the Plains. For two summers after college I worked on a cattle ranch in Wyoming, but it wasn't until I moved to Texas in the late seventies to teach photography that I began to explore this country in a north-south direction as well, first with a medium-format camera, and then, by the mid-eighties (by which time I had committed myself to an idea within this huge space), with a large-format camera and color film.

Initially, I simply wanted to come to terms with the remarkable flatness of the Texas Coastal Prairie, my new home, but as the photographs moved northward, the scope of my work grew, until the subject became the entirety of the western Plains, a thing of daunting size.

My idea, which this book describes, concerns a trip through the Plains—from open country to a small town, through this town, on to a larger one, and then out again into open space and sky. A simple idea, but one that's occupied me for over a dozen years and for many thousands of miles, and one that's allowed me to photograph anything of consequence on the land.

The land, of course, is one of extremes: great heat and droughts, more than occasional floods, biting cold and killing blizzards, tornadoes, and other storms that can, in an afternoon, wipe out a season's, or indeed a generation's work; there are even plagues of locusts that are biblical in dimension.

Yet all is housed within a space that, once one is accustomed to it, is as beautiful as any mountain range or ocean, and in its detail, as intimate as a backyard. The colors of the Plains don't leap out dramatically as they do in other landscapes, yet they have remarkable variance within their spectral bands—greens, browns, and blues, with the greens seeming to have the reach of a rainbow at times. There is the light, a light that moves from the softest and gentlest, to celestial beams of illuminating brilliance, to the blast furnace of noonday sun that subjects anything under it to a microscopic

scrutiny. There are towns that may appear crippled for economic reasons, but open like books, and hang onto life with a tenacity that is inspiring; and there are people—as varied as people anywhere, but taken as a whole, more than normally curious, approachable, and friendly.

The region has many problems, of course, verging from a prevalent absentee ownership, to a transient population that for centuries has tried to make a living without success; from the overuse of pesticides, herbicides, and fertilizers, to the one-crop economies that these tend to foster; from an American Indian population that has been dealt with brutally, to the local politics of any of these towns, which at times can seem both petty and harsh.

But the space is vast and meditative; the seasons are real and ever changing; the families are often more stable than their city counterparts; and the housing is cheap, the schools surprisingly good, the air fresh, and the country still open.

A final story: in the summer of 1993, I returned to Rapid City, South Dakota, after a week of photographing the flooding of the Mississippi River, an unusual subject for me. I was exhausted and slept fitfully for a day and a half. Homes slid into rivers in my dreams, and I saw the lives of families I knew washed away in moments.

I left Rapid City the next morning and drove south, down toward Chadron, Nebraska, happy to have space to fall into, and happy for the peace. I cut through Wounded Knee, the Pine Ridge and Rosebud Reservations, drove through Chadron, out to Fort Robinson, where Crazy Horse was killed, up into the Oglala Grasslands at dusk, and found my way out onto an old, white ranch road.

I followed it until it veered south, then got out of my car and started walking northwest with my camera over my shoulder, walking out into open space, to see what I could see. I walked and walked through that rolling countryside, past the remains of dugouts from the last century, past the ruins of wells and windmills, past coyote dens and badger tracks, and out into fields of cheatgrass, bluestem, and jimson weed. Hawks circled above me, soaring out over those low hills, and I walked on until I began to feel like one small, sentient dot on that vast sweep of plain.

As I went farther, thoughts began to come to me, humdrum thoughts really, but oddly reassuring ones nonetheless: that life, like these Plains, does in fact roll on, that time will not stop, that space itself, at times, is beneficient. And more locally, that despite the blood that had been shed on the ground on which I walked, despite the sad fact that few grass-

lands like it remain, despite the buffalo, elk, and indeed native people no longer roaming freely, despite a sad and troubling history, that these Plains were beautiful still—and continue to live with promise. That even with a record of siren-songed and dubious welcomes, one thing at least could be believed: that exultant, if short-lived peace would be known here again and again over time.

The peace that I was feeling that evening quickly dissipated, for as I surveyed the horizon, I saw that gigantic thunderheads had formed in the east. Mountainous blue-black clouds were already flashing lightning in the distance, and with night rapidly falling and this storm approaching, all my vague thoughts vaporized as it came to me that I was the tallest thing in this glorious space, that I was carrying a metal tripod, and that slung over my shoulder was a bag of anodized lenses.

So I stumbled back, like many before me, to a place of safety, in my case to my car and a skittering ride down that ranch road to a motel—rather than to a house in open space, or a snug home in town, or, as many have chosen after one surprise too many: to somewhere new—somewhere more predictable and stable, somewhere more economically viable, but somewhere certainly less compelling, vast, beautiful, and wild.

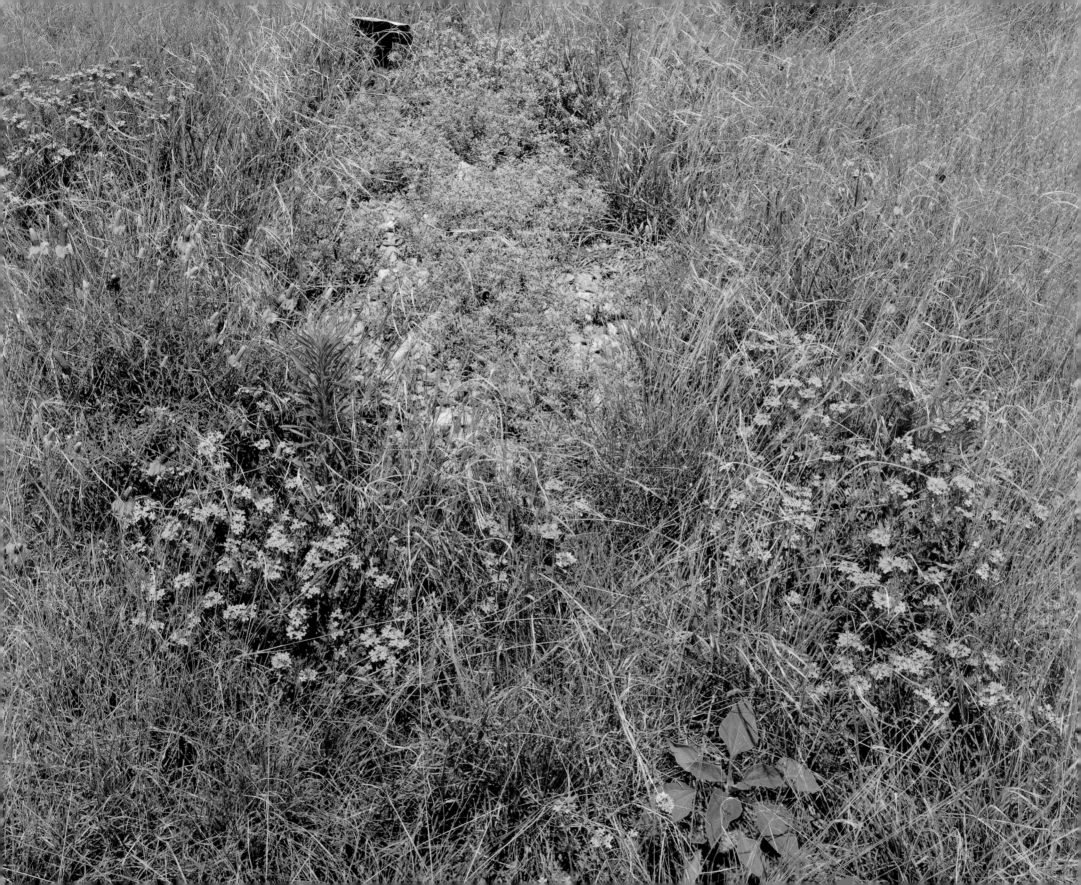

ACKNOWLEDGMENTS

I would like to thank the following foundations and organizations for their generous assistance: the National Endowment for the Arts; the Graham Foundation for Advanced Studies in the Fine Arts; Diverse Works and the Cultural Arts Council of Houston; the Cullinan Chair in Art, Architecture and Urban Design at Rice University; and the Center for Documentary Studies at Duke University. Without their assistance, the publication of this book would not have been possible.

I would like to thank Kathleen Norris for her beautiful introduction. She knows the world of the Plains well and communicates her knowledge with a grace that is inspirational. I am very grateful that she chose to write for this book.

I have been at work on these photographs for many years, and have many to thank. First, my family—my wife, Jill, and my daughter, Caitlin, who gave constant love and support on all phases of this work. Jill and Caitlin are my life. My love for each is boundless, and their help on this book was without limit.

I want to thank my parents, Robert McAfee Brown and Sydney Thomson Brown, in much the same way—for their compassion, for the half century of love they have shared, for their insistence on justice, for their embattled but unwavering Christianity—and for instilling in their children (among many things) a sense of adventure and an openness to new things. I want to thank my brothers, Mark and Tom, and my sister, Alison, for their intelligence, their sense of fun, their deep love, and for the continued tending of the spiritual fires that we were born into. I want to thank Paul, Karen, and Deb for marrying into our family and broadening it with their goodwill, thought, and heart; and I want to thank Colin, Aki, Jordan, Mackenzie, and Riley for the joyful presence that they bring, and for the future that they will shape.

I would like to thank my in-laws: particularly Jill's parents, Grace and the late Jack Fryar, both of whom knew the world described in this book intimately and who have helped Jill, Caitlin, and me in incalculable ways over the years. I would like to thank Jackie and Ray Thornton for their love, courage, support, and kinship; and all the Engdahl clan, who have opened themselves, and the country around Brady, Texas, to me in many ways.

At *DoubleTake* and the Center for Documentary Studies at Duke University, I am grateful to a number of people who have made this book possible. They are remarkable, and they deserve the gratitude of many for the talents, enthusiasm, fellowship, concern, and determination that they share. I want to express appreciation to Robert Coles and Alex Harris, who founded the Center and its pioneering magazine, *DoubleTake*. I want to thank them for their support of my work and for creating a beautiful venue for work like it. I thank Iris Tillman Hill, whose sharp eye, keen intellect, energetic spirit, and good

humor have made this book not only possible but a pleasure. To Molly Renda, whose transparent elegance as a designer brought the ideas that we had into sharp and beautiful focus; to Alexa Dilworth, who brought her skill as an editor and keen ear for tone to bear on all the writing in this book; to David Rowell, whose encouragement is infectious; to Caroline Nasrallah, whose work on my photographs in *DoubleTake* is greatly appreciated; to Rob Odom, whose boundless enthusiasm has encouraged my writing; to Annette deFerrari, who worked so hard on the production of this book; to Lauren Wilcox, whose assistance, humor, and clear eye have been indispensable; and to Tom Rankin, whose many talents, humane vision, and view of the future bode well for all—many, many thanks.

At W. W. Norton I would like to thank my editors Tabitha Griffin and Jim Mairs for the joy and commitment that they clearly feel for their work, for the enthusiastic reception that they gave mine, and for the grounded knowledge that each has of the country that this book represents.

I would like to express deep appreciation and affection to the following friends: to Don and Rebecca Minnick for offering a room in their beautiful home on Galveston Bay for use as a darkroom and for many years of friendship—and specifically to Don, for his insight over the years as image after image came downstairs; to Leo and Florence Holub of San Francisco—to Leo, who opened the world of photography to me as a teacher and since then, with Florence, has given years of friendship and support; to Robert and Kerstin Adams, who have offered support, great encouragement, and friendship and who have shared a life together that seems to point many of us in all the right directions; to the late John Brinckerhoff Jackson, who traveled with me in the early stages of this work and who taught me, both through his writing and our experiences on the road, what these small towns might be; to John Pack, Lynn Murphy, and Hanna Murphy-Pack for a deep and abiding friendship and for consenting to have at least one piece of art on their glowingly austere walls; to Ned Wolf, my oldest friend, for years of closeness, work, and fun; to the poet Susan Wood, whose mind and spirit are always open to me; to Steve Zamora, Tom Oldham, and Porter Storey, who have chewed over this work and the trials and tribulations of it at breakfast once a week for many years; to Bill and Ginny Camfield for their friendship, minds, eyes, hearts, and support; to Harrison Itz for being all that one would wish for in a dealer and friend; to Robin and Dick Brooks for years of friendship and for help in times of both celebration and need; to Jim Belli and Patricia Eiffel for their courage and the remarkable breadth of their concerns; to the Porter/Devries/Henry clan for Heath and all that word implies; to my California friends—particularly David and Ruth Kampmann, Lee Altman and Linda Grebmeier, David Gibson, and Bob Tyson for their intelligence, their eyes, and their eloquent understanding of riotous good times; to Max and Kathleen Sukiennik, Sylvia Bryant, Margaret and George Camp, and Sherry Fowler, a group who understands these times in Texas terms; to Don and Barbara Hopkins for their years of friendship; and to Daniel Kaufman, my wise helper through the minefields of academe—thank you.

Thank you to the following photographers, artists, writers, friends all, who have helped me find my way: to Adrienne Patton for the years with Caitlin, for inspirational work, and a genuine, searching life; to the late Charles Schorre for his example, his thought, his good humor, and all the careful listening that he gave to me; to Casey Williams for his generous mind, his individual eye, and his bedrock knowledge of all things Houston; to Drexel Turner for curating the first show of this work, for his friendship over the years, and for the driest humor in town; to Dick Wray for his boundless energy, iconoclastic spirit, puritan work ethic, unstoppable output, and generous encouragement; to Paul Hester for his intellect, his impassioned vision, and his wide-ranging concerns; to Fernando Castro for his

thoughtful imagery and lucid writing; to Ed Hirsch for the perfection of his words and his warmth; to George Krause for his visual quest, his passion, and his precision; to Fred Baldwin and Wendy Watriss, for Fotofest, a joined vision, and for abilities to do the impossible; to Sally Horrigan for all the roads shared; to Joan Myers for opening her home in Tesuque, for her friendship and her work; to Rob Riggan for his clear focus, his intensity, and his resolve; to Elie and Julian Hartt for their love of open spaces, their open minds, and their opened eyes; to Kevin Horan, my buddy on the Mississippi, for introducing me to the complexities of photojournalism; to Ron Jones for his adventuresome spirit and his consummate melding of Texas with California; to Joel Leivick for his sumptuous photography, his thoughtful mind, and his inspired stewardship of the Stanford photography program; to Mary Peck for the spare beauty of her work; to Ian Frazier for directing me through the Sand Hills, and for his wild and beautiful book *Great Plains;* to Jonathan Raban for *Bad Land;* and to Patrick Palmer, for his neighborliness, eclectic eye, and great generosity.

My thanks also to the following curators, each of whom has helped me see and better understand my own work: Peter Galassi and John Szarkowski at the Museum of Modern Art; Anne Tucker at the Museum of Fine Arts, Houston; Sandra Phillips at the San Francisco Museum of Modern Art; Lynn Herbert at the Contemporary Arts Museum in Houston; Emily Todd at Diverse Works; Drexel Turner at Rice University and the University of Houston; Roy Flukinger at the University of Texas at Austin; Barbara McCandless and John Rohrbach at the Amon Carter Museum in Fort Worth; Tom Southall at the High Museum in Atlanta; Suzanne Street at the Women's Institute in Houston; Chris Rauschenberg at Blue Sky Gallery in Portland, Oregon; Kenda North at the University of Texas at Arlington; Rod Slemmons at the Seattle Art Museum; and Catherine Wagner at Mills College. Thanks to you all.

I would like to thank Jean Caslin and Ann Shaw Lancaster at the Houston Center for Photography .

At Rice University I would like once again to thank Bill Camfield—also Andy Todd, Mary McIntire, and the late Jack Mitchell.

My thanks again to Harrison Itz, of Harris Gallery in Houston, as well as to Stephen Cohen of the Stephen Cohen Gallery in Los Angeles, and Rose Shoshana of the Gallery for Contemporary Photography in Santa Monica.

Two collectors, Bruce Berman and Martin Margulies, have been particularly supportive of my work, and I thank them as well.

At *Aperture* I want to thank Michael Sand and Melissa Harris.

And at *Life* I would like to thank Marie Schumann, and at *Vanity Fair,* David Friend.

Thank you to Jerry and Debbie Hagio, and all those at Hagio Photomurals in Houston, for developing thousands of four-by-five Vericolor III negatives and for maintaining a familylike atmosphere in a business that can oftentimes seem cool and impersonal.

My thanks also to the late Gealis, a cairn terrier who provided me with companionship on many of these trips.

And finally, to all those on the Plains who spoke with me, directed me, taught me, and on occasion posed for me, thank you. Your beautiful country has been a lifeline to me for many years.

INDEX